POSTCARD HISTORY SERIES

Williamsport

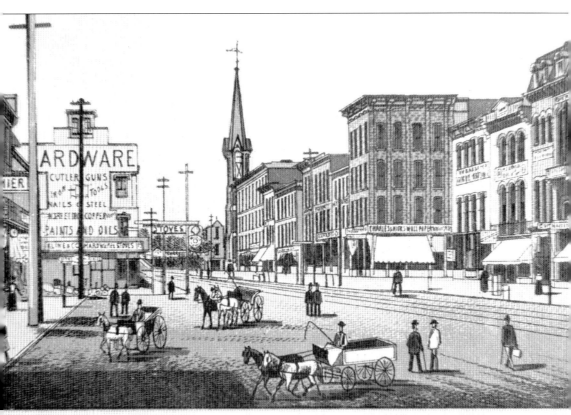

Published by Ely & Shempp, Williamsport, Pa

EAST MARKET SQUARE

This *c.* 1878 image portrays Williamsport's Market Square as it readies itself for the weekly Market Days, looking eastward to the original Millionaires' Row section of the young city where the early lumber barons, well-to-do merchants, and wealthy financiers of this local golden era built their stately mansions.

On the front cover: Williamsport's Market Square is seen in this *c.* 1875 view during the start of its Market Days, which served as the economic, cultural, and social center for the bustling pioneer city. See page 50 for further information. (Taber Museum Collection.)

On the back cover: Please see pages 102 and 107 for information. (Daniel Bower collection.)

POSTCARD HISTORY SERIES

Williamsport

Thad. Meckley
September 27, 2006

Thad Stephen Meckley

ARCADIA
PUBLISHING

Published by Arcadia Publishing
Charleston SC, Chicago IL, Portsmouth NH, San Francisco CA

Printed in the United States of America

Library of Congress Catalog Card Number: 2006924869

For all general information contact Arcadia Publishing at:
Telephone 843-853-2070
Fax 843-853-0044
E-mail sales@arcadiapublishing.com
For customer service and orders:
Toll-Free 1-888-313-2665

Visit us on the Internet at www.arcadiapublishing.com

To my darling daughter Ella Victoria and her loving mother Marla—the two great loves of my life. No greater gift can be instilled in my life than our wonderful memories and "adventures" shared together as well as your love (NAF) and support in making these first two books a success.

CONTENTS

Acknowledgments

This book would not have been possible without the help, motivation, spirit, and giving nature of so many people that have become a part of my pictorial view of Williamsport's saga during the first 100 years (1806–1906) via postcards during its bicentennial. Together with *Williamsport's Millionaires' Row*, I believe I have showcased what was, is, and shall ever be my beloved hometown of Williamsport, Pennsylvania.

Thanks goes out to Peter DiBartolemeo, whose bountiful collection of Williamsport postcards is once again instrumental in adding to the story that I wish to tell and teach within these pages. Pete exemplifies a proud Williamsporter who loves to share his passion for things Williamsport—namely postcards—with others, especially over a great slice of pizza at his family business, Bart's.

Along these lines, I would like to thank various other collectors, dealers, scholars, and friends who embody this same spirit: Daniel Bower; Brian T. Carson; the late Dr. Samuel J. Dornsife; Joe Epler; Reuhl Hartman, of the Susquehanna Post Card Club; Philip Sprunger; Barbara and Walt Fullmer; Robert E. Kane Jr.; Barbara Russell; Mike and Mike Callahan, of Callahan Antiquities; Virginia Springman; Karen and Jim Myers; Sarah Fagnano; the Lola Reese Spangle family; Michelle Kaiser Webb; Julie Dougherty, of the Lycoming College Archives; Thomas T. Taber III; my lifelong friends of the L. L. Stearns family; the Will Fluman family; the Roan family, of Roan Auctioneers and Appraisals Inc., a great source of acquiring Williamsport postcards and memorabilia; and mural artist Michael Piclato.

I would like to offer thanks to Joanne Stetts-Maietta for use of her extraordinary Williamsport and Newberry card collection and memorabilia that has helped further the story told in so few images but truly worth a thousand words. Visiting her beloved home, Hickory Hill, in Newberry is truly a step back in time.

Thank you to Sandra Rife, executive director, Scott Sugar, curator, and Conni Robinson, gift store manager, of the Lycoming County Historical Society and Thomas Taber Museum.

Thank you to my amazingly talented, loving, and gifted friend Melinda Hevner Saldivia. Thank you for coming into my life to help not only make these books great and for "coming home" to Williamsport to be here in my time of need, but to connect with me as a lifelong friend. You're the best.

Also, I would like to thank Matthew Klinepeter, my in-house computer guru, for all things computer-oriented as well as the folks at the James V. Brown Library.

And, to Erin Vosgien and the Arcadia staff for all their guidance and expertise in making this book a reality.

Finally, I could not have completed this monumental project without the support and motivation of my friends and family, especially my amazing daughter Ella Victoria Meckley. Thanks guys, I hope I did you all proud again!

INTRODUCTION

Call it fate as you may, but this book, and *Williamsport's Millionaires' Row*, was truly written in the cards for me—postcards actually. While I had contacted Arcadia several years ago in hopes of writing a book or two on local history, I put the idea on the back burner until fate came knocking at my door—literally in the form of a postcard—sent by my great grandfather in 1932 that came to my front door three Christmases ago.

For a mere $1.95 on eBay I unknowingly bought part of my family heritage and garnered the thought of sharing this event and such cards with others. From that day forward, fate keeps sending me notes in the form of postcards and pictures to tell me that I am on the right path in writing these books.

Furthermore, when I just happened to reconnect with a wonderful local family, the Carson's, who were mutual friends of my late friend Sam Dornsife, I found a postcard in their collection sent by my great-great grandfather to other relatives of mine in nearby Nesbit, Pennsylvania. What are the odds that twice now I came across such postcards—messages from my own relatives long ago?

In addition, my daughter Ella is named after "Stella" that being Estella Huber Kolb, my one maternal great grandmother, mentioned on the Carson's card. While Estella and Stella were considerations, Marla and I decided upon the name Ella Victoria in April 2002 after her; my other maternal great grandmother, Ella Neitzel LaGrange; Marla's special great aunt, Ella Mickey Evans, and Marla's fraternal grandmother, Bertha Victoria Mickey. So, I think our "special ladies" are truly smiling proudly from above as they watch over our little sweetheart, dropping tales of our past and heritage in the form of postcards from Williamsport and Minersville, Pennsylvania, to teach her more about her unique Mickey-Meckley family heritage.

Putting this book together has been a true labor of love. The countless hours of interviews and meeting of new acquaintances and friends have become wonderful memories. Who would have thought that I would reconnect two other families, the Bower and Earon-Myers families, with multiple postcards and photographs from direct relatives generations back while rummaging through antique shops? Thus, the journey has continued to provide flavorful postcards and tales as part of the making of this publication and the spirit within the collectors selected exemplifies why I wanted to write this book. It melds the history and architecture of Williamsport's "two" Millionaires' Rows with the family heritage and stories of so many, including my own, while educating people. This book hopefully will evoke community pride and respect for the heritage of each reader's own family. Whether rich or poor, a long-time resident, a passing glamorous society figure, or a lasting legacy, all played their part in forming Williamsport.

As for the history of postcards, I offer the following brief, condensed lesson for those not familiar or knowledgeable in the philatelic evolution.

In Europe, postcards were made available for sale due to the Post Office Act of 1870. In America, they went on sale in 1873. But, it was at the World's Fair in 1893 that postcards became

all the rage when picture postcards became available, being sold from vending machines to the thousands of new technology-curious visitors.

Great Britain followed suit by making picture postcards available in 1884. But, it was Germany that seemed to lead the way for both ideas and quality in printing of postcards. Likewise, the gruss aus (Greetings from) cards from Germany are the forerunners to the popular American versions of souvenir postal greetings, some of which are featured in this book. This is the type familiar to all having traveled to various beaches or summer resorts where such are made available at the token two-for-$1.00 price.

Further, in 1907, the practice of writing on the same side as the address became permitted in the United States as at first many just simply sent or "exchanged" cards with whom they addressed them to. Thus, today we have little clues as to the names of the senders of many such early cards.

The postcard-sending craze was said to continue up until the 1940s and 1950s when it fell out of favor. Today the Internet reigns supreme as the way to go for sending news and quick hellos. Furthermore, the genre of sending postcards takes on the latest, less permanent state in the sending of electronic postcards.

While an e-mail postcard is nice to receive, I still prefer and enjoy the real thing. Hopefully, you to will rethink your interest and use of postcards, both those available to buy and those of long-ago relatives tucked away in your attic. Many involved in the writing of this book already have been touched with the "postcard bug," experiencing renewed interest and appreciation of the collecting, and sending too, of postcards. Happy hunting and enjoy!

This postcard from the past was sent from the author's great-great grandfather to relatives of the author's great-grandmother's side of the family, providing a rare connection to relatives he never met. This was discovered by the author in a collector's cards while doing research.

One

Jaysburg (Newberry)

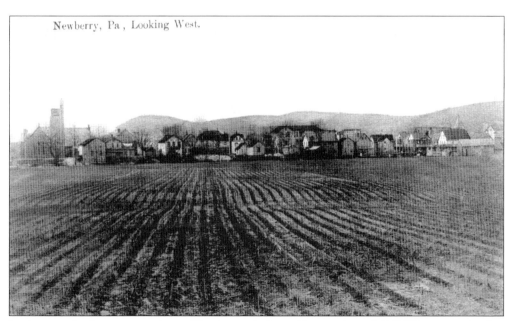

Newberry, Pa., Looking West.

Jaysburg, today known together as Newberry, is the earliest section of all Williamsport, having been settled in 1774 by the pioneer families of John Sutton and William Culberston. Sutton bought his "New Garden" tract in Newberry in 1786 from Richard Penn. In the distance you can see the Presbyterian Church along Arch Street with the fields in the foreground prior to the development of housing sites along Race Street, which got its name from water race that went down to the Goods City Mill. (Stetts-Maietta collection.)

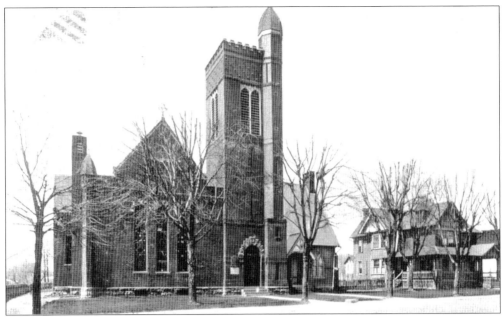

The Lycoming Presbyterian Church is the oldest church in not only Newberry and Williamsport, but also all of Lycoming County, being founded in 1792 by early traveling Methodist missionaries who organized in 1786. It serves as the oldest Presbyterian Church in all of the West Branch Valley where the missionaries helped bring their faith to the settlers. This brick edifice was erected in 1891, replacing an outgrown, smaller one, which was dedicated in June 1854 by former Pastor John H. Grier, who was ordained as its first permanent minister. (Stetts-Maietta collection.)

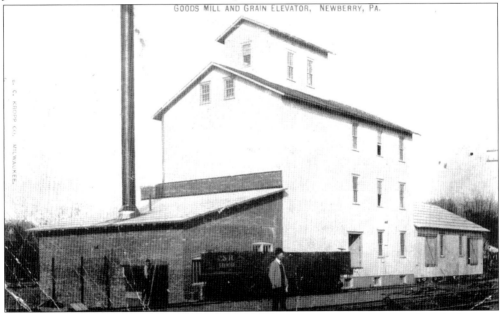

Still in use at 2117 Webb Street in 2006 as the Good's Wholesale and Bakery Supplies, the business is located in the Jaysburg section of Newberry. This view shows the rear of the operation, which looks the same today as it did then with truck loading replacing that of railroad shipping and unloading. (Stetts-Maietta collection.)

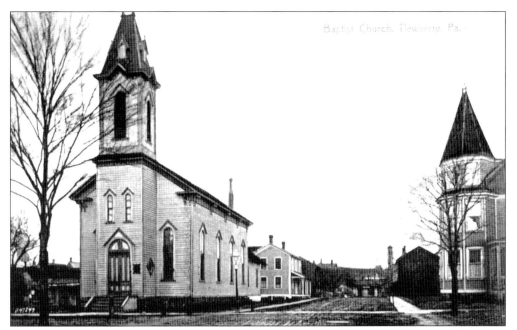

The old wood-sided Second Baptist Newberry Church (Third and Depot Streets), seen here, was replaced by a newer Victorian stone church. The church was formed when employees from the Dodge Lumber Mill, of whom many lived in nearby 'Dodge Row" company housing on Arch, requested a house of worship of their own. Mill superintendent E. B. Campbell was instrumental here in assisting these and other lumber boom workers. (Stetts-Maietta collection.)

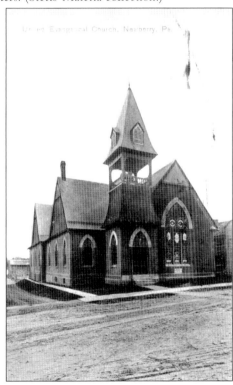

The United Evangelical Church was erected in 1871 on Race Street below Apple Street at a cost of $3,000 with seating for 300. (Stetts-Maietta collection.)

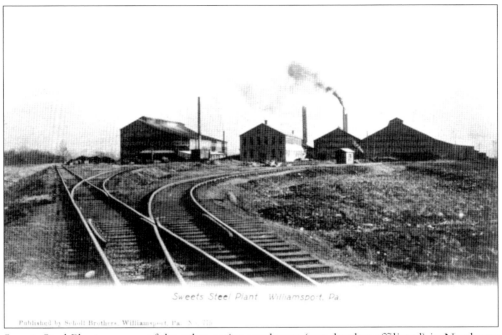

Sweets Steel Plant was one of the other major employers (non-lumber affiliated) in Newberry for decades since its arrival in 1903, when it was constructed after its mother-plant in New York State was dismantled and removed to this location. They manufactured high-grade open-hearth steel of a variety of specialized shapes and sizes, including reinforcement bars for concrete, tire steel, and "cast steel" hammered tools. (Springman collection.)

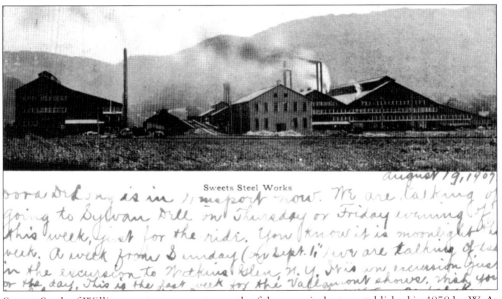

Sweets Steel, of Williamsport, was an outgrowth of the same industry established in 1858 by W. A. Sweet and Brothers, of Syracuse, New York. This vintage view was sent to relatives, telling tales of trips to local Sylvan Dell Park and the Vallamont Park shows. (Stetts-Maietta collection.)

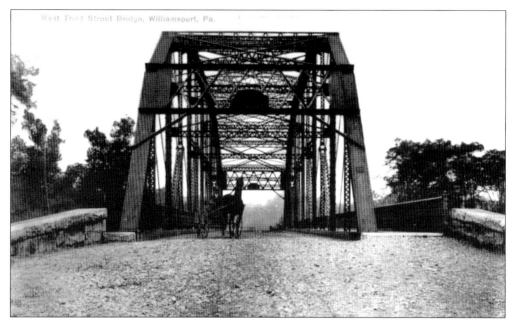

This old iron bridge connected the lower south side of Newberry, being the original settlement of Jaysburg, which at one time battled for the Lycoming County seat. Peter Herdic "tricked" petitioners in signing for the placement of the county courthouse, altering the document to state they were in favor of Williamsport, not Jaysburg, for this honor. (Springman collection.)

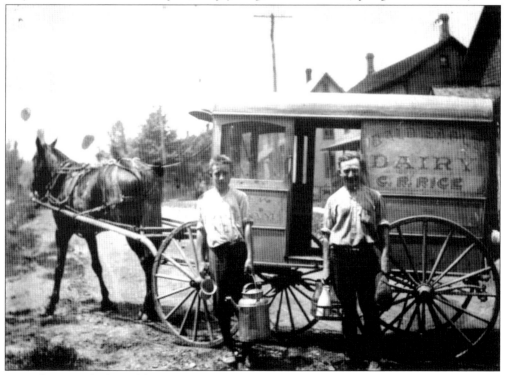

One of many early dairy delivery services in Newberry during the late Victorian Era, C. R. Rice Bald Eagle Dairy's wagon is shown during a milk delivery run. (Stetts-Maietta collection.)

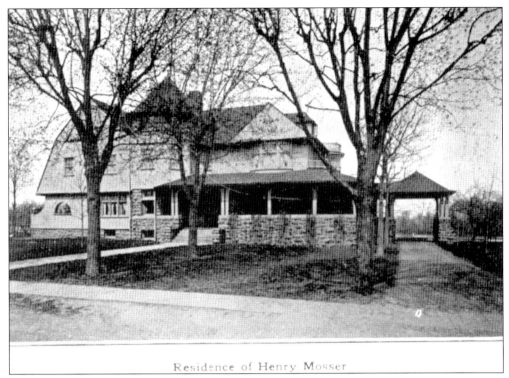

Residence of Henry Mosser

In this real-photo postcard, the J. K. Mosser estate in Newberry is seen in early spring. (Springman collection.)

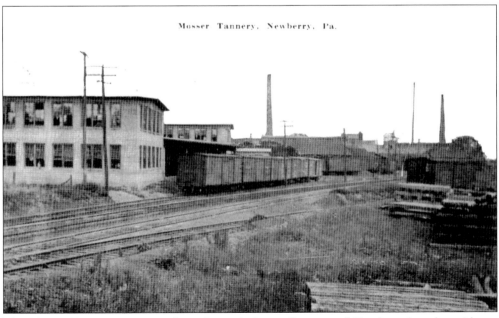

The Mosser Tannery was an early mainstay industry for most of Newberry's male residents. J. K. Mosser owned and operated this tannery, using bark from lumber timber industry to tan the hides. (Stetts-Maietta collection.)

The J. K. Mosser homestead was thought to be the most beautiful structure in Newberry, being situated in the old Jaysburg section. It was demolished in the late 1960s after it suffered a severe fire in February 1967. (Stetts-Maietta collection.)

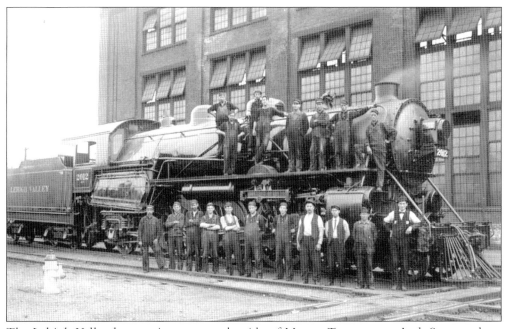

The Lehigh Valley locomotive stops at the side of Mosser Tannery, on Arch Street, where employees strike a pose for a company photograph. The Reading Railroad line also served Mosser Tannery. (Stetts-Maietta collection.)

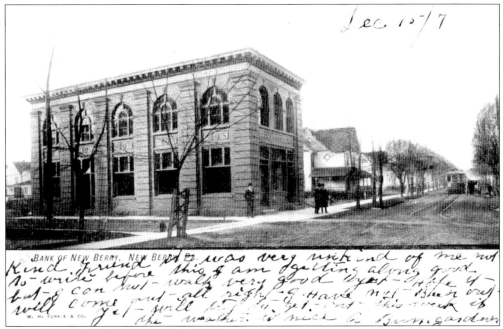

This was the original Bank of Newberry, located on the southwest corner of Water and West Fourth Streets. In later years, a five and dime store operated next to the bank, with old Dr. Ellis having his dental office on the second floor. (Taber Museum Collection.)

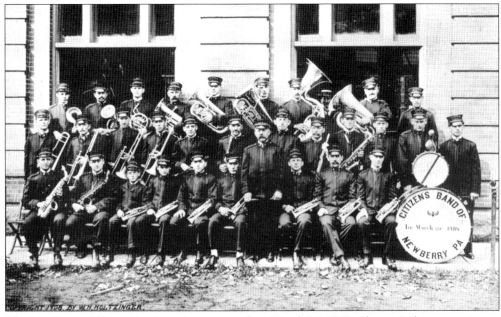

The Newberry Citizens Band was incorporated on March 20, 1908. Shown is the group picture taken with 31 members present. Williamsport was known for its fine brass instruments made locally, and this view shows these in use. (Stetts–Maietta collection.)

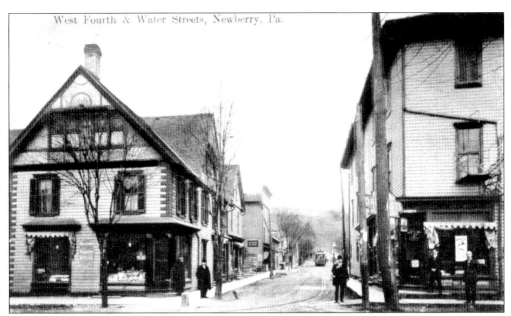

Located on Dewey and Water Streets, the original Odd Fellows Hall and post office building has since been replaced by the World War I monument, being known as the intersection at Monument Square (now Arch and West Fourth Streets). (Stetts-Maietta collection.)

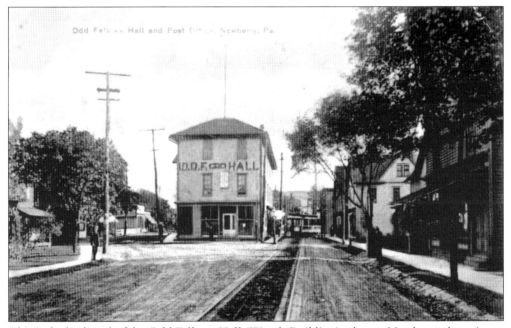

This is the back end of the Odd Fellows Hall (Woods Building) where a Newberry druggist set up shop at the corner of Water and West Fourth Streets. The unique, eclectic Victorian-style home to the left has been replaced by a former "filling station," which is an automobile repair shop in 2006. (Stetts-Maietta collection.)

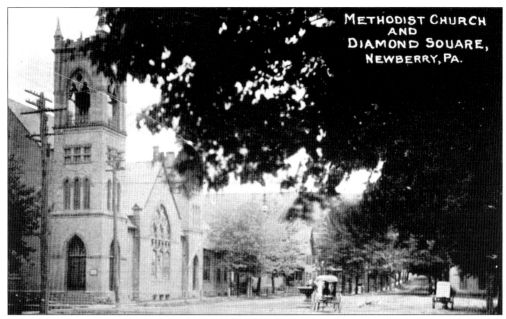

Diamond Square epitomizes what is Newberry, being its original residential square. The Newbery Methodist Church recently ceased operating as a religious center and rents this fine stone edifice. The iron fountain seen here has been relocated—much to the displeasure of old-time Newberry residents—to the front lawn of Williamsport's old city hall on Pine Street. One can almost hear the carriage clip clopping on the redbrick-lined Diamond Square streets. (Daniel Bower collection.)

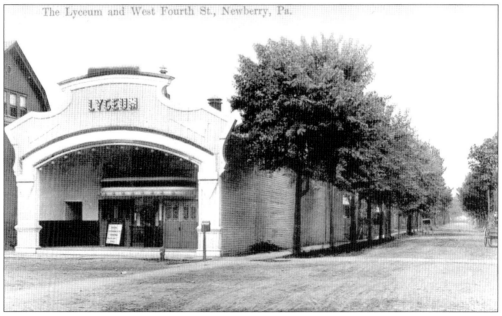

This Diamond Square view shows the old Lyceum Theater, and 845–847 Diamond Street, which was built by the Updegraff family, who also lived at 841 Diamond, is seen just off to the left. Both buildings still stand today; the theater is now a dollar store and the 1905 brick house is divided into apartments. (Stetts-Maietta collection.)

18

This early 20th-century postcard depicts part of Diamond Street, which ran south from Newberry Street to the Pennsylvania and Eerie Railroad, featuring 846 Diamond Street in the left foreground. After having been the home of Dr. Frank Bell, the first president of the Bank of Newberry, this Victorian has been used as Sander's Mortuary (which has been in business since 1938) since 1946 and is still in business there today. (Stetts-Maietta collection.)

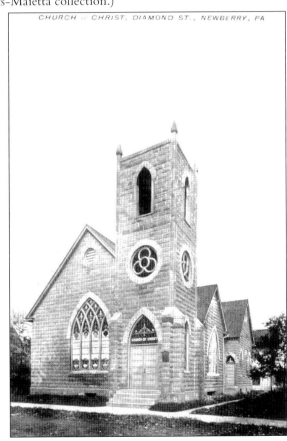

Newberry's Episcopalian Church of Christ was erected in the late 1800s at 822 Diamond Street. This structure was torn down in the late 1960s and replaced by a modern church building, which now is used by the Newburry Church of Christ. (Stetts-Maietta collection.)

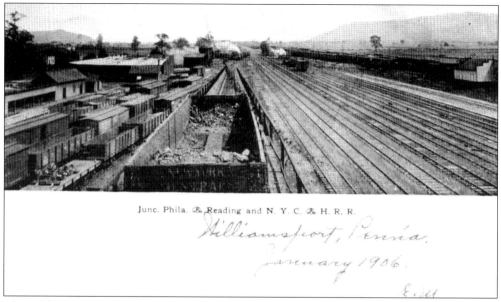

Junc. Phila. & Reading and N. Y. C. & H. R. R.

Williamsport, Penna.

January 1906.

E. M

The mighty junction of the Newberry Yards is legendary both then and now across the country. This 100-year-old postcard illustrates the busy railroad comings and goings of the day of the Philadelphia and Reading (later the Pennsy) Railroad and the New York Central and Hudson River Railroad. Trains still use the yard tracks daily in 2006, but sadly not to the extent shown. (Springman collection.)

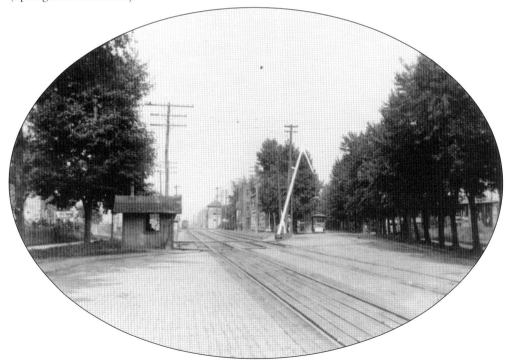

This unique oval view shows the West Fourth Street junction of the Pennsy line with the railroad's watch box on the left and its Fifth Avenue tower in the distant middle. Note the Newberry trolley approaching. (Stetts-Maietta collection.)

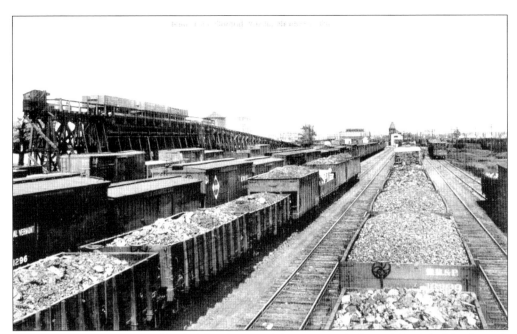

More comings and goings of loaded freight cars of the New York Central Yards in Newberry is depicted here, looking east back into Williamsport. (Stetts–Maietta collection.)

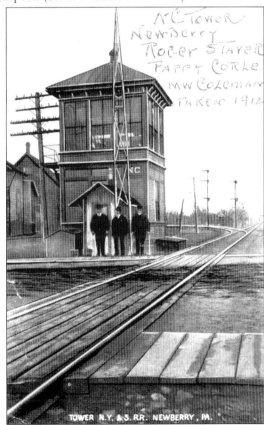

The imposing New York Central Railroad Tower is viewed close up with employees Rodger Staver (left), Pappy Corle (center), and M. W. Coleman (right) shown in 1912. (Stetts–Maietta collection.)

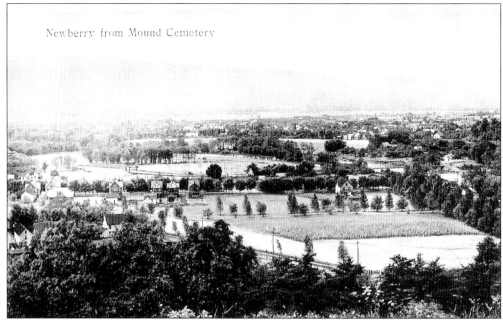

Newberry from Mound Cemetery

This picturesque view shows Williamsport leading into its Newberry section from the Mound Cemetery section of Wildwood Cemetery. Note the two-span Blaine Street Trolley Bridge (center right), which connected with the Newberry streetcar line running up Water Street to West Fourth Street and then to Diamond Square, the turnabout point for trips back into Williamsport. (Daniel Bower collection.)

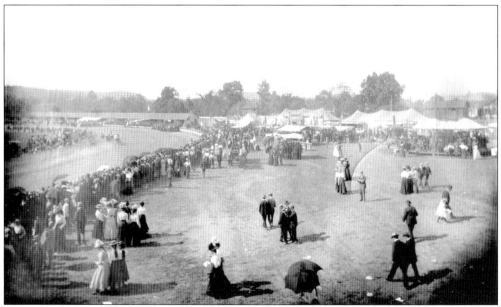

This image shows spectators at an early Williamsport horse racing track with the horses at full speed. The track's location in the city can be seen from the postcard above. This is the site of today's Bowman Field, the second oldest professional minor league stadium in the country. (Will Fluman collection.)

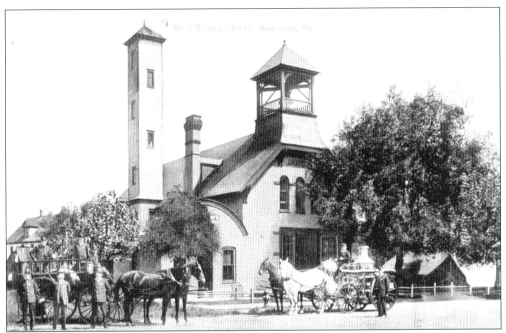

The No. 5 Engine House of the Williamsport Fire Department was built on Federal Avenue just off Arch Street facing to the south of the railroad tracks. It is revamped and adapted now for use as a car repair shop operation in 2006. (Stetts–Maietta collection.)

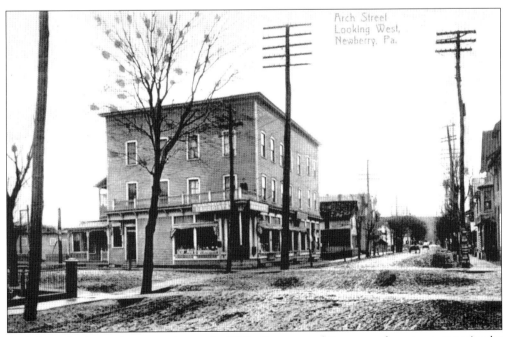

Arch Street looks northwest to picture the W. R. Runner and Company drug store, opposite the Winner-Franck Bakery, the forerunner of the later Capital Bakery. This is the intersection of Elm Street (presently known as West Third Street) and Arch Street. (Daniel Bower collection.)

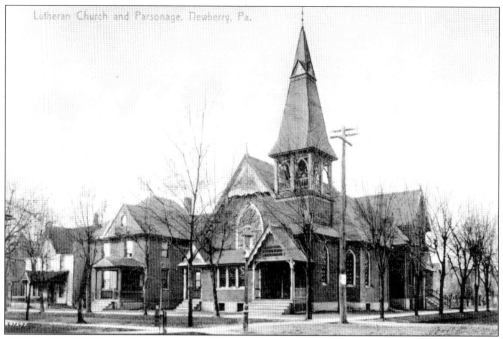

St. Matthew's Lutheran Church was erected in the 19th century at the corner of Pearl and Linn Streets, making its mark as one of Newberry's leading and most beautiful houses of worship. In 1892, Rev. Leander Goetz led the congregation while he resided at the nearby home of Newberry veterinarian John Patterson, at 122 Diamond Street. (Stetts-Maietta collection.)

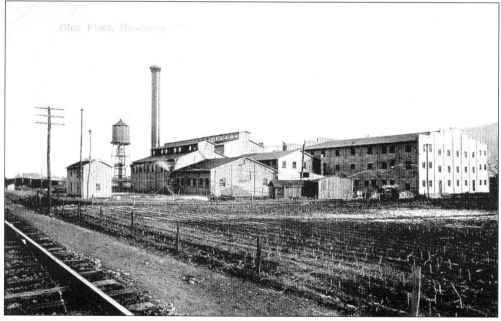

The Keystone Glue Plant was one of the earliest industries in Newberry, being situated on the upper end off of West Fourth Street. This West End business used the railroad link in the Newberry Yards to ship its products. In 2006, it is now the Lonzza Chemical Company, formerly known for years as the Glyco Chemical plant. (Stetts-Maietta collection.)

Two

THE ORIGINAL MILLIONAIRE'S ROW

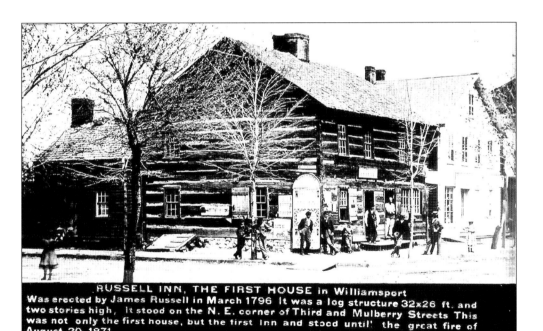

RUSSELL INN, THE FIRST HOUSE in Williamsport
Was erected by James Russell in March 1796 It was a log structure 32x26 ft. and
two stories high, It stood on the N. E. corner of Third and Mulberry Streets This
was not only the first house, but the first Inn and stood until' the great fire of
August 20, 1871

The Russell Inn and Tavern was the hub of Williamsport until its destruction in the great fire of
1871, when most of the downtown was destroyed. Across from its site on the northwest corner of
East Third Street and Mulberry Street, Williamsport saw its first Victorian commercial business
block using steel framework to be built. This brick masterpiece still stands in its entirety in
2006. This area marks the birthplace of Williamsport, especially its commercial business district.
(Daniel Bower collection.)

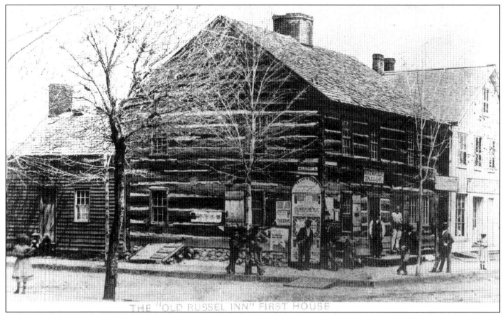

Not only did the Russell Inn birth the law in early Williamsport, holding court sessions there until 1798, but Russell's widow gave birth there to daughter Eva "Affie" Dumm, Williamsport's first child in 1806, the same year as Williamsport's founding as a city. (Carson collection.)

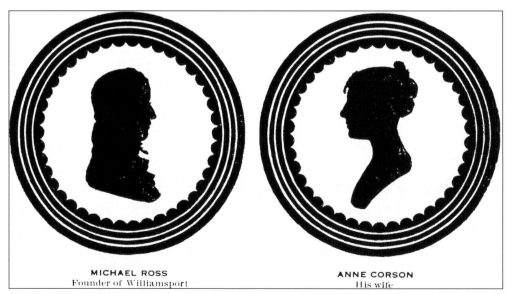

MICHAEL ROSS
Founder of Williamsport

ANNE CORSON
His wife

This charming silhouette of the Ross couple, Michael and wife Anne Ross (née Corson), commemorates Williamsport's founding family. Michael, who first worked as an indentured servant to Samuel Wallis, of Muncy, later worked his way to become a surveyor's assistant. Later, Michael would use these acquired skills to help lay out Williamsport from his 285-acre purchase from a William Winter. (DiBartolomeo collection.)

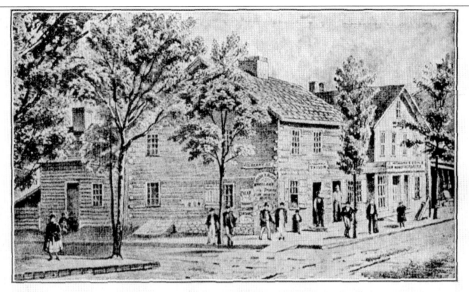

RUSSELL INN---FIRST HOUSE IN WILLIAMSPORT
N. E. corner Third and Mulberry Sts. Destroyed by fire Aug. 9, 1871. First Williamsport child born here.

Russell Inn was the first house built in what became the city of Williamsport in the spring of 1786. It was a log home, located on the northeast corner of East Third and Mulberry Streets. The site of the house is currently a municipal parking lot. (DiBartolomeo collection.)

The William Hepburn house was known to be the second brick home built in Williamsport, sitting in the heart of Hepburn's 300-acre Deer Park estate. Located at the foot of Park Street, the mansion was the elegant homestead to William Hepburn, Lycoming County's first state senator, associate judge, president judge, and master of the local Blue Lodge Free and Accepted Masons. Hepburn is regarded as one of the leading figures that helped establish as a city and as the county seat. (Thad Meckley collection.)

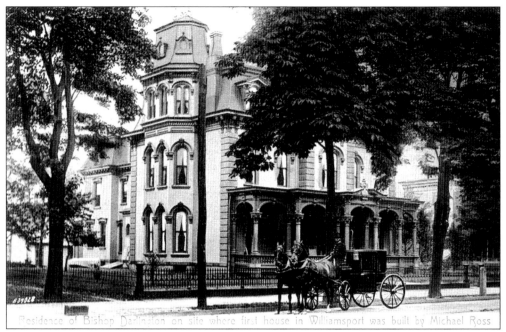

The site of Bishop Darlington's residence was where Michael Ross, Williamsport's founding father, built his first house in Williamsport in 1803. The massive eclectic early Williamsport Victorian mansion was built as the James Vanduzee Brown Residence in 1875. The bishop used the Williamsport home as his Bishopric summer residence (1906–1908) while he wintered in the Harrisburg Bishopric. (Thad Meckley collection.)

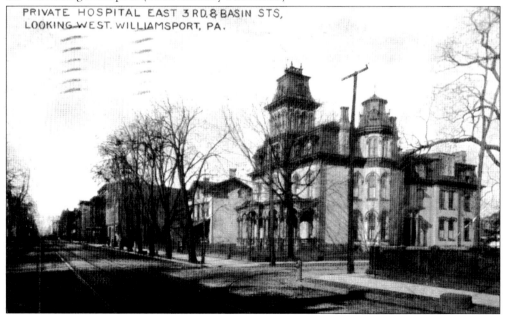

In 1818, after the death of Michael Ross, his estate was sold to a Mr. Cowan, a land developer and speculator. Years later, lumber baron James V. Brown bought the Ross residence and lived there with his family. Brown had the 1803 brick house demolished to make way for his palatial Victorian mansion at the corner of East Third and Basin Streets. (Stetts-Maietta collection.)

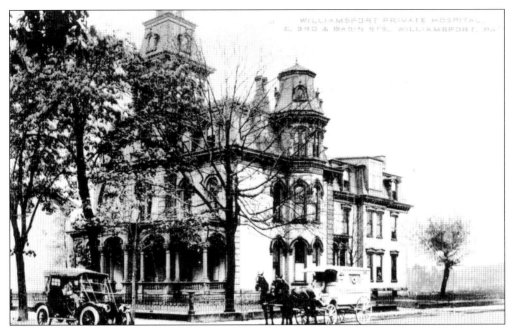

The Brown mansion was later revamped into a private hospital by Dr. Albert F. Hardt. The local surgeon provided a home for nurses in the building's rear. It was the hospital nurses that discovered the building burning during the early morning hours of January 28, 1918, taking themselves, patients, and staff from the blazing building. (Stetts-Maietta collection.)

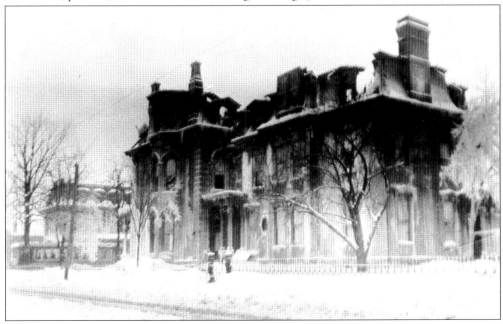

Sadly, the former Brown family mansion burned to become an ice-covered shell of its former self before having to be razed. The ornate wrought iron fence remained on site for some 80 years before being rescued by Brown's benefactor, the James V. Brown Library. The stately L. L. Stearns family mansion is seen here from across the street, showing a rare eastern vantage view of this now-gone beauty. (Will Fluman collection.)

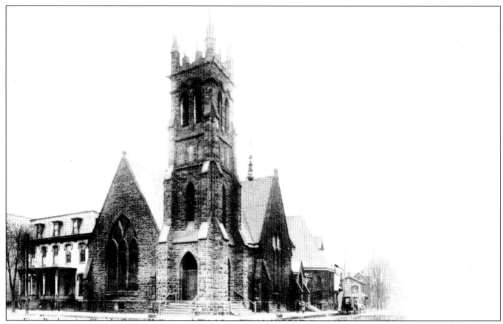

The First Presbyterian Church, located at the corner of East Third and Mulberry Streets, was built in 1882–1884, costing a staggering $65,000. The manse next door to the stone edifice was used by the church minister and their families up until a Walnut Street manse was purchased. (Private collection.)

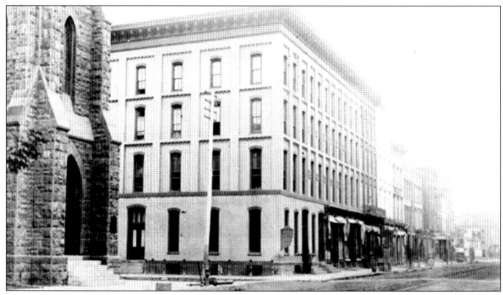

The First Presbyterian Church's spire has since been removed, but the interior sanctuary below is in more original condition having been restored in 2001 by local decorative artist Marguerite Bierman. (DiBartolomeo collection.)

Lumber baron and church member J. Walton Bowman gifted the tower chimes and a four-manual Austin organ in 1925 to First Presbyterian, prompting many changes to the sanctuary area. Tiffany's, of New York City, embellished the chancel wall behind the pulpit area with a magnificent, ornate cross which is highlighted in gold leaf amongst the art nouveau hues of the period. (DiBartolomeo collection.)

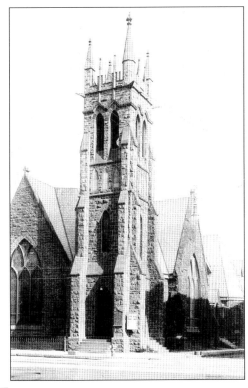

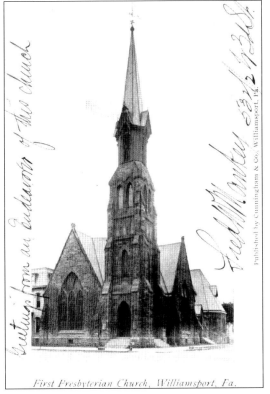

First Presbyterian Church, Williamsport, Pa.

The First Presbyterian Church listed members that included "the elite" of Williamsport, including the John B. Coryell, Frederick Mankey, L. L. Stearns, John B. Hall, John G. Reading and Gov. William Packer. Coryell was said to help select the church's plot, as it was near his East Third Street residence so he could walk to church, giving his coachman Sundays off. And, it helped rebuild and stabilize the neighborhood, having been decimated by the great fire of 1871. (Thad Meckley collection.)

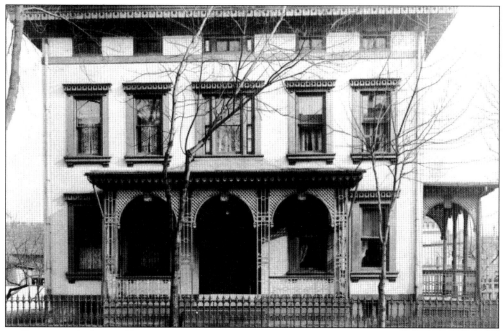

Williamsport's first self-made millionaire George Winter Lentz built this incredible early Victorian mansion (140 East Third Street) along the original Millionaires' Row, which ran along East Third Street between Mulberry and Penn Streets. Lentz was an early business partner with Peter Herdic, forming the Herdic, Lentz and Whites (John and Henry) lumber concern. (Stetts-Maietta collection.)

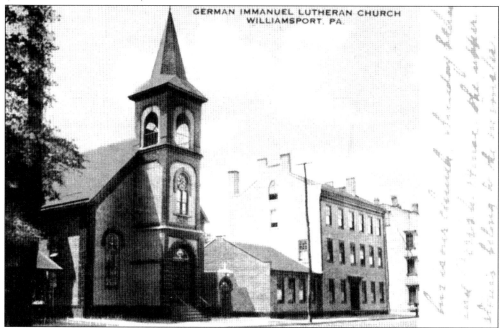

The German Lutheran Immanuel Church, located at 214 East Third Street, was built to seat 450 parishioners, many of whom were of German descent and lived nearby in the "Dutch Hill" section around the Penn Street and Washington Boulevard area. (DiBartolomeo collection.)

Luten Legge (L. L.) Stearns and his family lived at 236 East Fourth Street along the original row of newly made millionaires. His Mansard-roofed mansion, seen in this real-photo postcard, is but a memory like the legendary department store he founded, built, and passed on to future generations in the Stearns family. Prior, the Stearns family lived at 92 Market Street, just around the corner from the family business on Market Square. (L. L. Stearns family collection.)

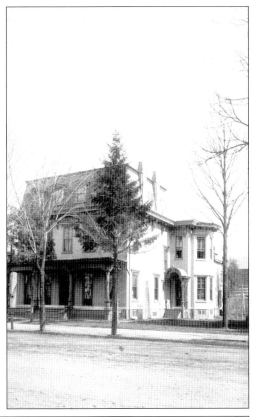

Surviving is a trade card from the Market Square locale of L. L. Stearns and Sons, 1 East Third Street on Market Square, after the store moved from Jersey Shore, Pennsylvania, via wooden raft on the Susquehanna River in the spring of 1865. (L. L. Stearns collection.)

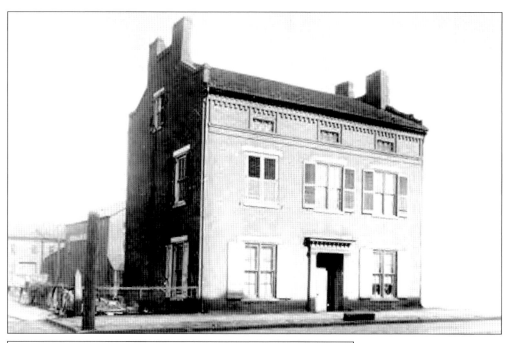

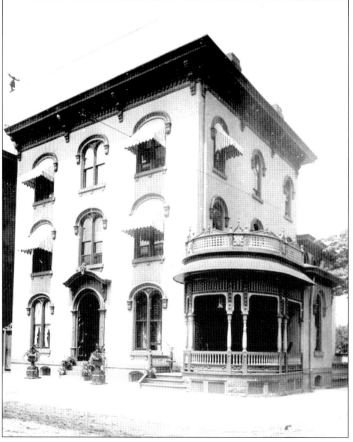

Pictured are the Millionaires' Row homes of Tunison Coryell (above) and son John B. Coryell (left). The elder Coryell (Tunison) was a leading citizen and pioneer during the early days of settling the West Branch Valley. Lawyer John Coryell (Coryell and Collins) was secretary and treasurer of the St. Mary's Coal Company and a partner in the Coryell Flint Paper Company, which manufactured glue and flint papers. (Private collection.)

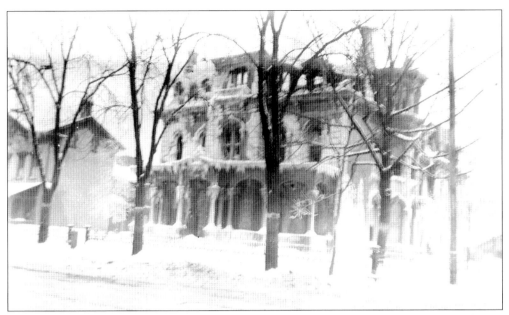

The former James V. Brown mansion stands in ruin under the frozen waters used to save it during the early morning hours of January 28, 1919. To the left, the Henry Ulman residence, located at 225 East Fourth Street, remained unscathed. Ulman, of the Ulman Brothers clothier family, located at 5 West Third Street, worked in the real estate business. (Will Fluman collection.)

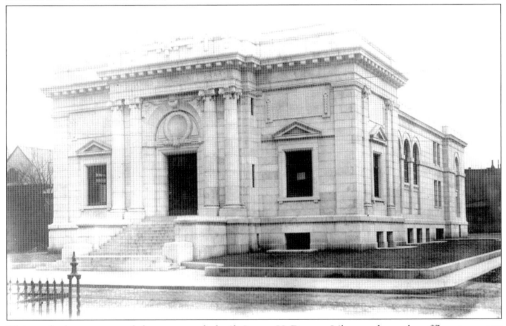

This real-photo postcard shows a newly built James V. Brown Library along the affluent avenue of East Fourth Street. It was neighbors with the stately homes of Williamsport's early millionaire families. Note the ornate wrought iron fence of the Piper mansion, both now gone. Built in the Beau Arts–French Renaissance style in white marble and grey bricks, the library was designed by nationally noted architect Edgar V. Seelar with funds donated by Brown, whose family founded Brown University in Rhode Island. (Thad Meckley collection.)

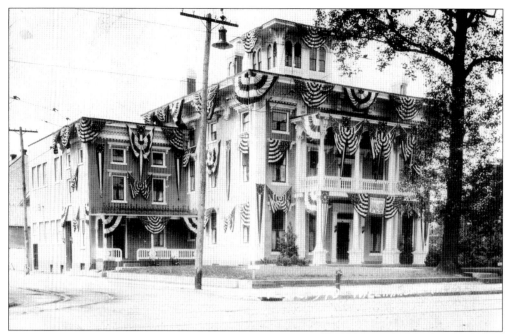

The Eagles Social club building was originally a girl's academy in 1820. It became home later to the prominent Williamsport families, the Whites and later the Evendens, who modified the massive brick mansion with Victorian embellishments. The building on 307 West Third Street is still home to the Williamsport Aerie No. 970 Fraternal Order Eagles organization in 2006. (Above, Thad Meckley collection; below, Will Fluman collection.)

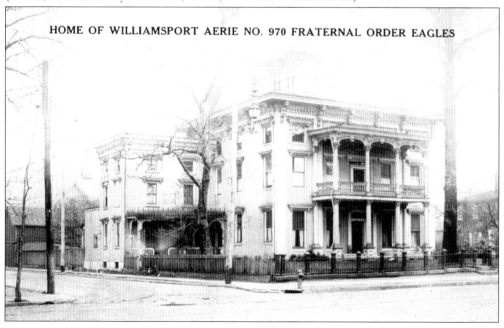

HOME OF WILLIAMSPORT AERIE NO. 970 FRATERNAL ORDER EAGLES

Dr. Donaldson, of 620 Vallamont Drive, operated a private hospital in the former Judge James Gamble mansion at 106 East Fourth at the southeast corner of East Fourth and Mulberry Streets. With its ornate cupola removed and its original windows replaced, the stately Victorian remains in otherwise good repair, being used as an apartment building. (Carson collection.)

This picturesque scene shows some of the early downtown Victorian structures along Mulberry Street, including the former Lutheran Church, which sat near the corner of East Fourth and Mulberry Streets until its demise during a string of arson fires in the 1970s. (Thad Meckley collection.)

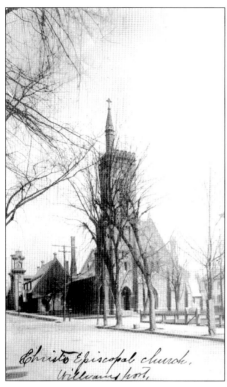

Christ Episcopal Church, Williamsport,

A real-photo postcard view of Mulberry shows not only Christ Church but also (Fire) Engine House No. 1, located at 434–438 Mulberry Street. Designed by architect Eber Culver, the "Independence Engine house" was demolished in later years and stands clear in 2006 as a parking lot for Lycoming College. Thomas Pursel, of the famous local Pursel firemen family, worked and lived here. (DiBartolomeo collection.)

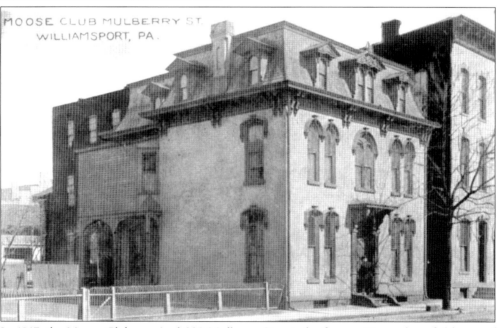

In 1917, the Moose Club acquired 320 Mulberry Street, the former Mansard-roofed home of Nathaniel B. Bubb, who moved to the former residence of Peter Herdic, 407 West Fourth Street, in 1892. Nathaniel was son of wholesale grocer George Bubb, of Geo. Bubb and Sons (N. B. and Harry C.). The Bubb's were also lumbermen, engaged in the N. B. Bubb and Company (H. C. and G. Bubb) at 108 West Fourth Street. (Thad Meckley collection.)

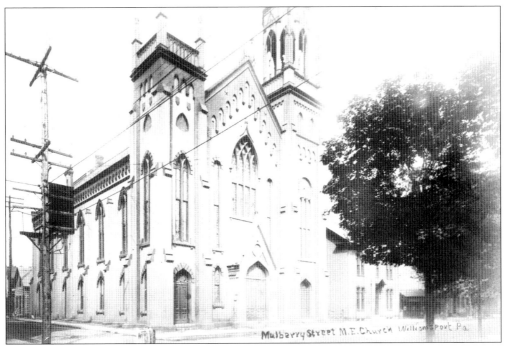

The Mulberry Methodist Episcopal Church, located at 335 Mulberry Street, was incorporated in 1863, having a series of fires and mishaps until its final demise in early February, 1973, which the author witnessed sadly as a small boy with his mother, sister, and brother. The first church burned in 1868, was rebuilt in 1869, burned again and was rebuilt in 1871, had its steeple blown down in June 1876, and was repaired and reopened in 1878. (Stetts-Maietta collection.)

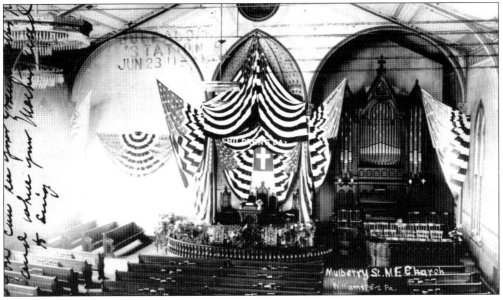

The Mulberry Methodist Episcopal Church interior shows the 1871 edifice's sanctuary decorated before its 590 seats for worship. The structure was sold in 1963 to the congregation of the Faith Tabernacle Church. The red-metal roofed, brick church Parsonage, at 345 Mulberry Street, still stands and is a home and private practice office building. (Taber Museum Collection.)

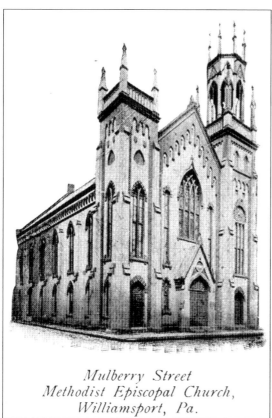

Mulberry Street Methodist Episcopal Church, Williamsport, Pa.

The Mulberry Methodist Church sat on the north side of the corner of Willow and Mulberry Streets, which is now a parking lot area in 2006. (DiBartolomeo collection.)

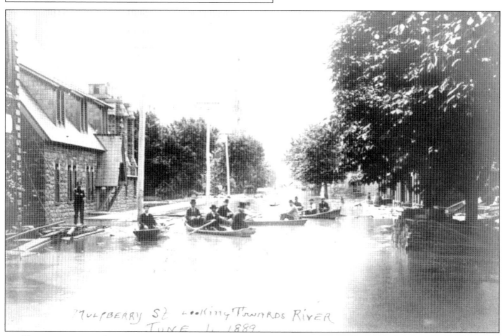

Williamsporters take to their boats to navigate Mulberry Street during the big June Flood of 1889 as seen in this real-photo postcard. (DiBartolomeo collection.)

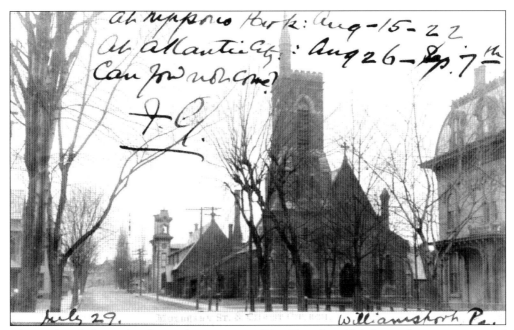

Christ Church, located at the northeast corner of East Fourth and Mulberry Streets, was erected in 1869 after outgrowing its 1842 homestead at the corner of East Third and Basin Streets. Purchasing two adjoining lots, the congregation hired architect J. F. Miller, of New York, and laid its cornerstone on June 27, 1867. (Springman collection.)

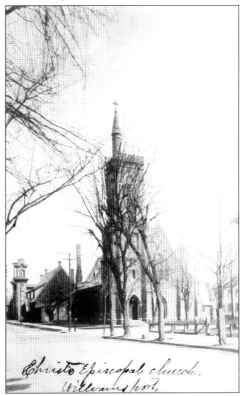

Christ Church celebrated its first liturgy on Christmas Day 1869. The "original" Millionaires' Row church had the honor of having its 1879 consecration performed by Dr. John Henry Hopkins, who is best known for penning the 1857 Christmas carol "We Three Kings," being written before arriving in Williamsport. (DiBartolomeo collection.)

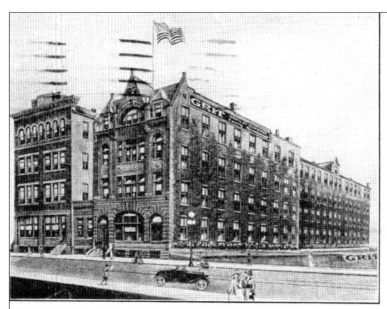

THE HOME OF GRIT—AMERICA'S GREATEST FAMILY NEWSPAPER

Deitrick Lamade, *GRIT* newspaper's founder, made his early family home at 122 East Fourth Street before building his Victorian mansion homestead at 746 West Third Street. Architectural interior details from the nouveau-riche house are identical to those found on the exterior of the Pennsylvania *GRIT* building, designed by Eber Culver as well. (Springman collection.)

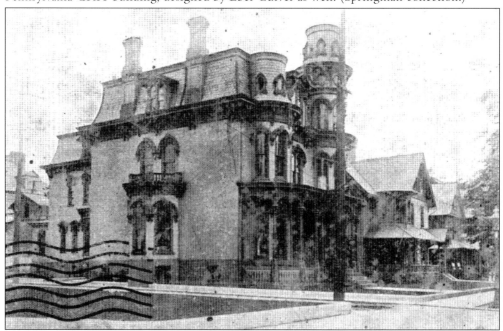

The Henry Brown residence, located at 17 East Fourth Street, was moved across State Street to build the James V. Brown Library, before it was transformed into the Democratic Club house. It met its demise in 1983 to make way for a modern structure that is said to embody the spirit of the design of the former lumber baron mansion. Henry, brother of James V., was a partner in the Earley, Brown and Brewster lumber firm, of 50 West Willow Street. (Springman collection.)

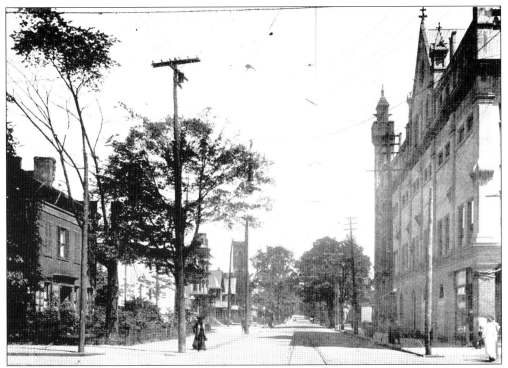

This East Fourth Street view shows the home of former Pennsylvania governor William Packer, the James V. Brown Library, Henry Brown, William Sprague, and Mrs. George Slate on the right of the brick-paved road and the Masonic Howard Memorial Building to the right. (Thad Meckley collection.)

East Fourth Street was the home to some of Williamsport's leading families—the Ayers, Lundy, Gamble, Flock, Denworth, Piper, and Steumple families. (Myers collection.)

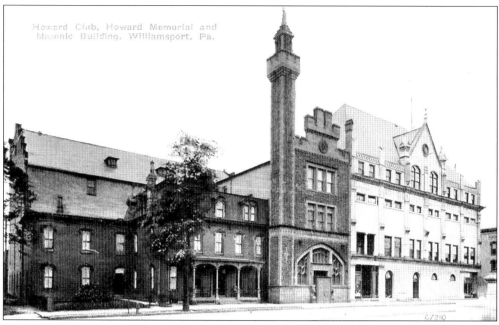

The Howard Club was the former family home Edmund Lear Piper, who was related by marriage to neighbor James V. Brown, with whom he was partners in Brown's business interests. Likewise, lumber magnate William Howard gifted to his local Masons the Piper residence, becoming known as the Howard Club. Edmund and his wife, Harriet Piper (née Watson), coincidentally "reside" next to the Browns in Wildwood Cemetery. (Fullmer collection.)

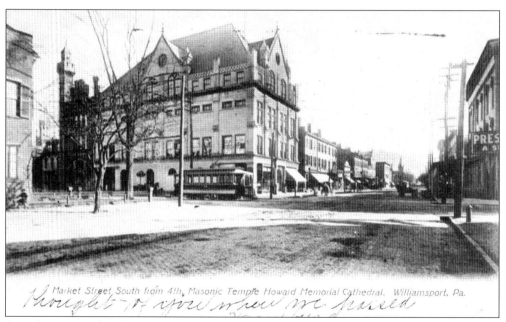

A southeast view of Market and Fourth Street allows for an interesting vantage of the Parsons–Packer home, the Piper residence (Howard Club), and the lofty spire of the First Presbyterian Church, just visible beyond the keep tower of the Howard Memorial building, which was the former site for the Presbyterian church. (Fullmer collection.)

Three

Downtown
Williamsport

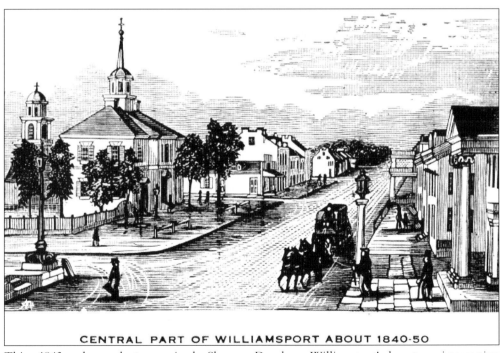

This *c.* 1843, early woodcut engraving by Sherman Day shows Williamsport's downtown intersection at Pine and West Third Streets, looking westward to its early residences and businesses in the center of the young frontier town. On the left is the original county court house while diagonally across the street is the Greek Revival–style Eagles Hotel. (Thad Meckley collection.)

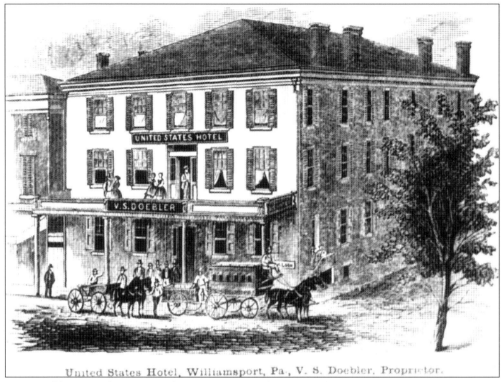

V. S. Doebler not only operated the U.S. Hotel on the corner of West Fourth and William Streets as shown, but also was one of the leading businessmen in Williamsport, having a frequent hand in its formation in the early days. (Thad Meckley collection.)

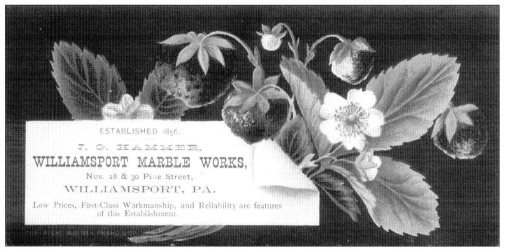

J. G. Hammer was a leading and noted marble dealer in Williamsport, being one of the early successful building supply houses. Established in 1856, Hammer's operated in the thick of the lumber trade business at 28 and 30 Pine Street, being located adjacent to many of the leading lumber barons, attorneys, and businessmen. (Thad Meckley collection.)

BEEDE, BURROWS & CO.,

WHOLESALE

GROCERS

AND TEA MERCHANTS,

AGENTS FOR

THE WELLMAN & DWIRE TOBACCO CO.'S

CELEBRATED "SILVER THREAD" FINE CUT CHEWING TOBACCO.

COR. FOURTH AND WILLIAM STS.,

WILLIAMSPORT, - - PA.

This postcard was used as an advertising trade card by long-time merchants Beede, Burrows, and Company (Frank J. Burrows and Thomas Polleys), located at the corner of West Fourth and William Streets. The Alexander Beede property was later sold on Friday, November 1, 1907, to A. F. Young, of the Bush and Bull Company. This was one of the author's earliest finds and one of the priciest until recent years. (Thad Meckley collection.)

Dealers in books, stationery, wallpaper and window shades, Hicks and Burnley, located on Market Square at 14 West Third Street, is actually the predecessor to Otto's Bookstore, operating in 2006 in the heart of downtown Williamsport at 107 West Fourth Street. (Thad Meckley collection.)

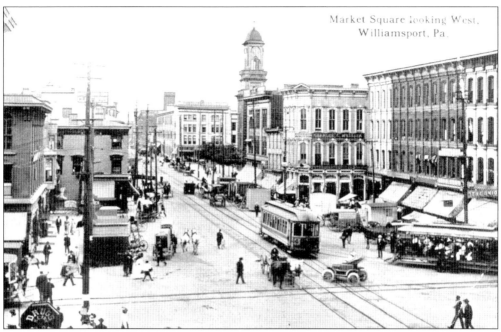

Premier jeweler Charles B. Mussina's shop is immortalized as a part of the hustling trade center on Williamsport's Market Square during the Victorian Era. The Mussinas are one of Williamsport's oldest families, which includes New York Yankees pitcher Mike Mussina as a descendant. (Callahan collection.)

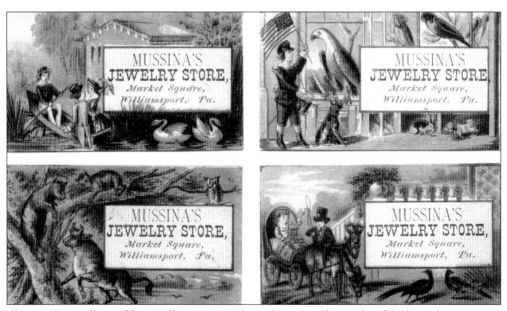

Illustrated is a collage of four Williamsport trade cards, noting the works of the legendary Mussina family jewelers. (DiBartolomeo collection.)

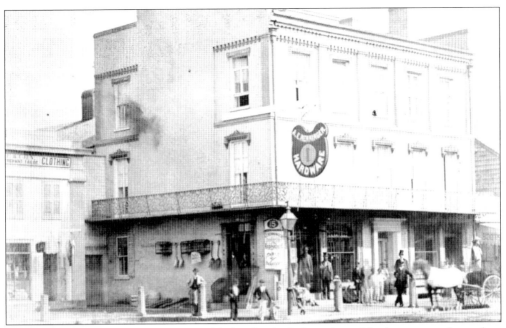

This incredible real-photo postcard highlights the A. C. Renninger Hardware store, located on the northeast side of Market Square. This Greek Revival–style structure was built as the home of Robert Faries, who was in charge of selecting the site for and design of the Williamsport and Elmira Railroad, for which he was compensated $2,500 annually. (Taber Museum Collection.)

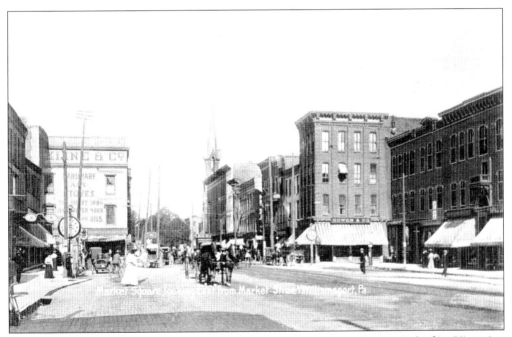

Seen here is an early view of Williamsport during the construction period of its Victorian commercial-style central Business District, looking east from its Market Square to its prestigious row of newly made millionaires' homes along east lower East Third Street. (Stetts-Maietta Collection.)

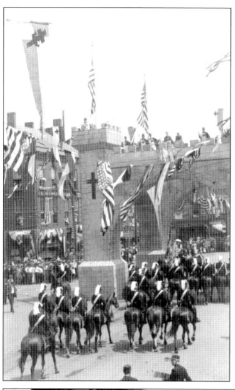

The Masonic influence on Williamsport is depicted in this real-photo postcard of a Knights Templar celebration parade in downtown Williamsport. (Springman collection.)

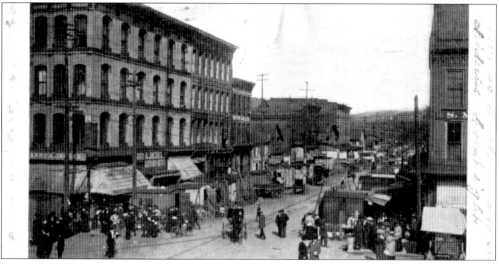

The writer of this card used every inch to say, "My Dear Boy, I am 10 doors this side of 3rd St. on Market St. Every Wednesday and Saturday morning they have what they call Market. Farmers, butchers, est. come in for miles with everything to eat. Those that come regular have a regular place in front of a particular store, paying the city $3.00 per month and 50$ each Market Day they come. Butchers mostly use those frame houses on 4 wheels, storing them on vacant lots other days at 8.00 per year. I counted over 40 back of a big barn. They have to take off their shoes. Normally by 10 o'clock men, women and children with baskets on their arms buying everything to eat . . . even two live chickens. Great Sight. Wish you all had been here." (Fagnano collection.)

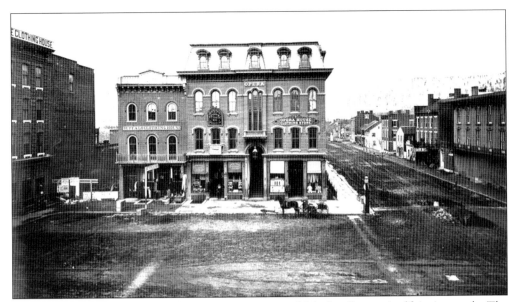

This *c.* 1875 view shows the Ulman Opera House and Market Square itself, in its youth. The Ulman Opera House, located at 4 East Third Street, was the leading entertainment center for Victorian Williamsport society, hosting such notorieties as actress Lillian Russell and humorist and writer Mark Twain (also known as Samuel Clemens). (Private collection.)

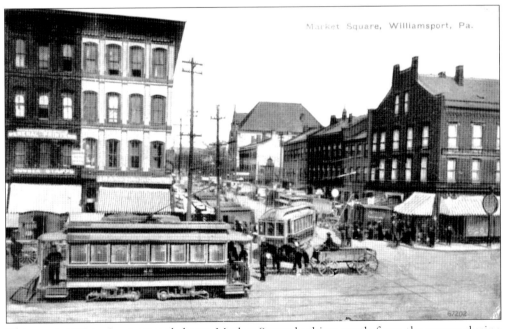

This quaint Victorian postcard shows Market Street looking north from the square during Williamsport's Market Day. It is said that more than $1 million changed hands during a given year here at its height. (Springman collection.)

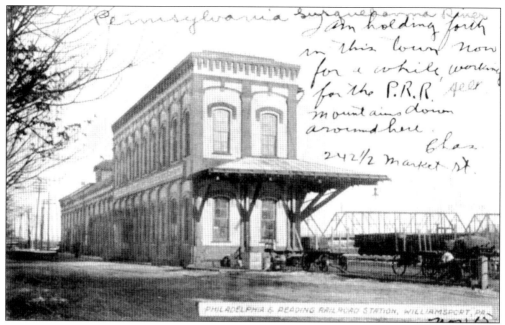

On May 26, 1871, ground was broken for the Philadelphia and Reading Company Passenger Depot in downtown Williamsport where it stood for nearly 100 years at the foot of Pine Street. The maiden passenger train pulled into town on November 30, 1871. During its heyday in the 1920s and 1930s, some 12 passenger trains would be pulling in and out daily before it met its close on January 7, 1950. "The Williamsporter" was fondly its most popular train, running service between Williamsport and Philadelphia each way overnight. (Stetts-Maietta collection.)

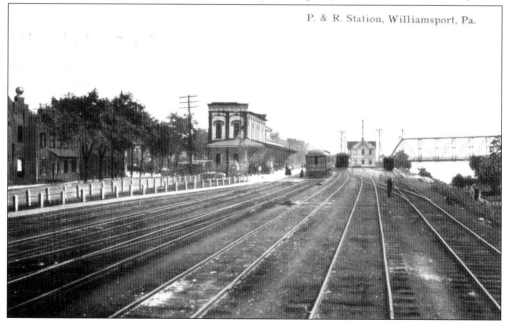

The Philadelphia and Reading Station was demolished to make way for the city's new beltway road system as part of Williamsport Redevelopment Authority's Canal Street project in the 1970s, having sat vacant for nearly 20 years. (Stetts–Maietta collection.)

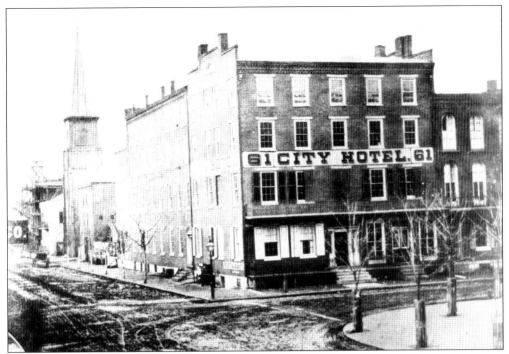

The City Hotel operated on the same site that became home to the legendary L. L. Stearns Department Store. The church in the background was the former GAR home. (L. L. Stearns family collection.)

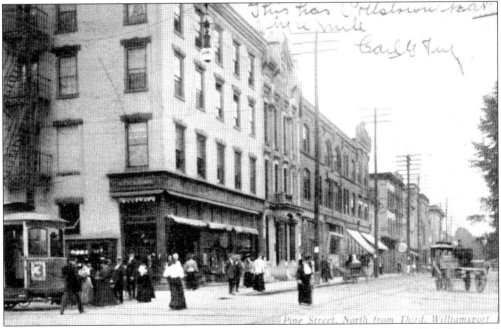

L. L. Stearns was the leading department store in the region, fascinating visitors with its "modern" ways and captivating window displays. (DiBartolomeo collection.)

An amazing and rare 1906 view of Pine Street shows the L. L. Stearns Department Store and the West Branch National Bank leading off the line-up of select shops and businesses in downtown Williamsport. The West Branch Bank had its charter proposed on February 13, 1834, in the Pennsylvania Legislature. The bank began operations on May 23, 1838, offering engraved $5, $10, and $20 notes. (DiBartolomeo collection.)

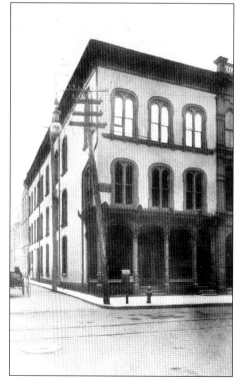

This image shows the Italianate-style facade of the Williamsport National Bank, one of downtown's oldest residents, of 329 Pine Street, before being resurfaced and its windows and architectural details remodeled. Elias Deemer served as the first president of the bank, which was authorized by a special act of Congress on December 18, 1870. Deemer was succeeded by his son, William R. Deemer. (Private collection.)

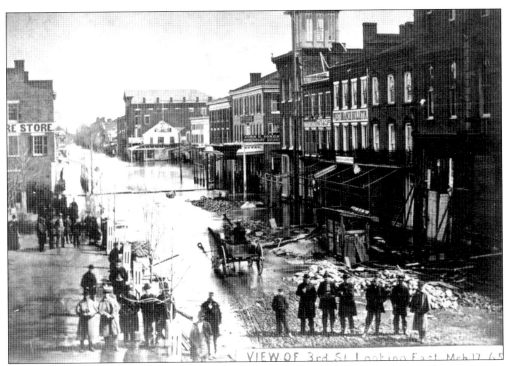

The St. Patrick's Day Flood of 1865 is shown having ravaged West Third Street in downtown Williamsport. (Private collection.)

The 1869 Lycoming County Courthouse was the third building constructed for such a purpose on the same site, which was occupied by the first until its outgrown demise in 1858, and this second architectural gem until its shortsighted demise in 1969. Nationally renown Philadelphia Architect Samuel Sloan designed this building and others similar to it in Lock Haven and Sunbury town squares—both of which still stand in 2006. (DiBartolomeo collection.)

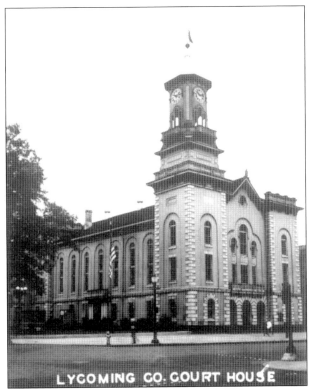

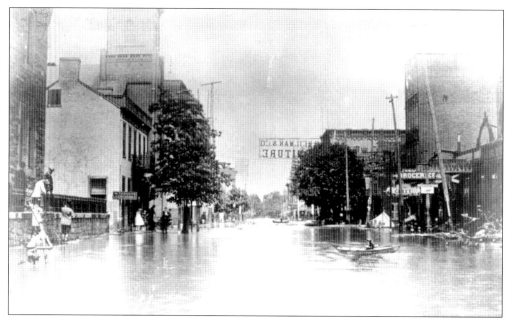

Another flooding of the mighty Susquehanna River is shown after the devastation it ravaged upon the downtown Williamsport Business District. (DiBartolomeo collection.)

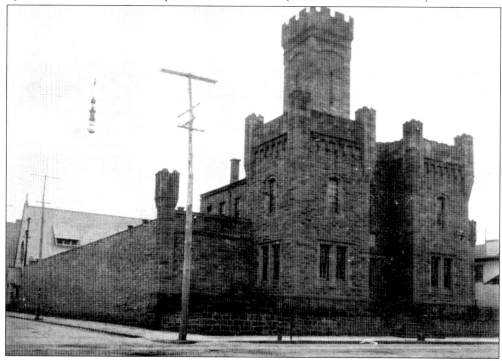

The former Lycoming County Jail was built in 1868, being designed by famous prison architect John Haviland. Today the stone edifice operates as a local bar and restaurant establishment with the former cells serving as dining areas. Much of the original layout of the unique structure is still in its original form, located on the northeast corner of West Third and Williams Streets. (Thad Meckley collection.)

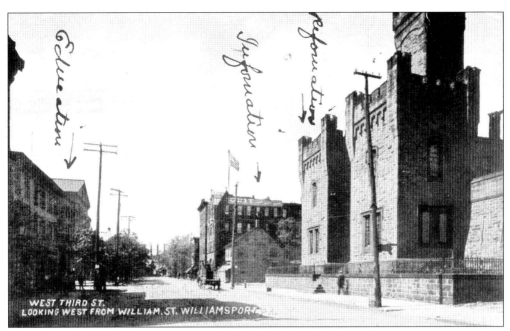

The writer of this West Third Street postcard points out an interesting occurrence. One can seek reformation in the Lycoming County Jail, information from the *GRIT* newspapers, and education at the George Washington School. (Thad Meckley collection.)

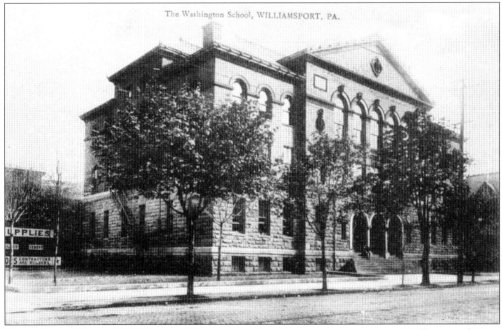

Shown is the George Washington School, located at the southwest corner of William and West Third Streets, with a glimpse of the Huffman Builder's office and its advertising wall facade. The school was built as a larger replacement for the former Washington school, a two-story, eight-roomed brick building. (Thad Meckley collection.)

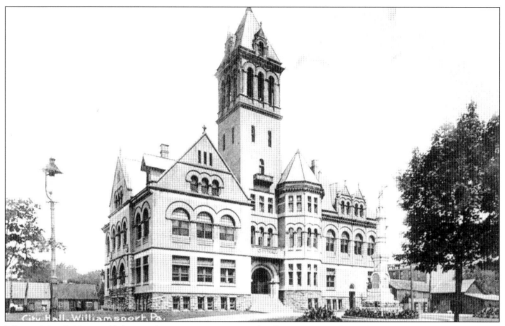

The original City Hall, located on Pine Street, was built in 1894 and was designed by Williamsport's illustrious architect Eber Culver. This National Registry building sits on the site of the former Ross Cemetery, which was moved to nearby Williamsport Cemetery. But before, in December 1869, Mark Twain wrote his famous piece, "Remarkable Dream," after seeing the decrepit condition of the old burial grounds. A large granite marker in the upscale Wildwood Cemetery notes the move of the hallowed grounds oddly enough as well, being done perhaps out of shame once Twain's piece was published. (Thad Meckley collection.)

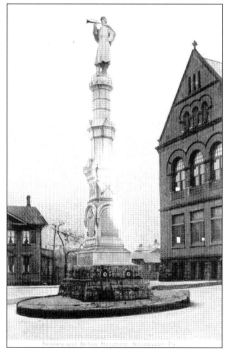

Williamsport dedicated this marble monument to the soldiers and sailors of the Civil War, placing it appropriately in front of the then city hall building. (Thad Meckley collection.)

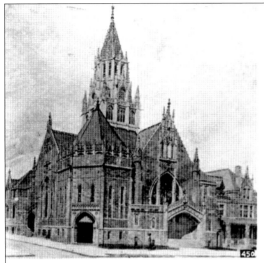

THE EPWORTH League of Pine Street M. E. Church earnestly requests your subscription or renewal to THE LADIES' HOME JOURNAL or THE SATURDAY EVENING POST—or both. A liberal part of the money will go to our society, and possibly a large cash prize. Will you assist us? Would not THE JOURNAL and THE POST make splendid gifts to your friends? If a renewal, to be started at the expiration of a present subscription, please state that fact. The subscription price of either Magazine is $1.50.

Kindly make check, money order or express order payable to I. S. Mabee, and mail to him, Post Office Box 231, Williamsport, Pa., or to me.

Will you kindly help us?

Sincerely yours,

THE NEW PINE STREET METHODIST EPISCOPAL CHURCH
(UNDER CONSTRUCTION)

Plans for the new and third Pine Street Methodist Church were released and unveiled in this vintage postcard. The finished product is shown below. Tragically, it burned in the 1970s during a string of arson fires. (DiBartolomeo collection.)

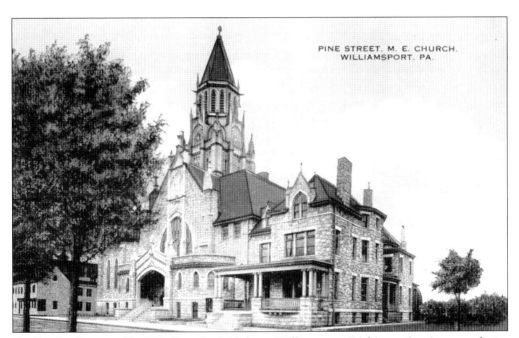

PINE STREET. M. E. CHURCH. WILLIAMSPORT. PA.

On Sunday, January 23, 1910, Rev. E. A. Pyles, a Williamsport Dickinson Seminary graduate, dedicated the church, which was well attended by both seminary students and faculty. The original church was dedicated in 1844. (DiBartolomeo collection.)

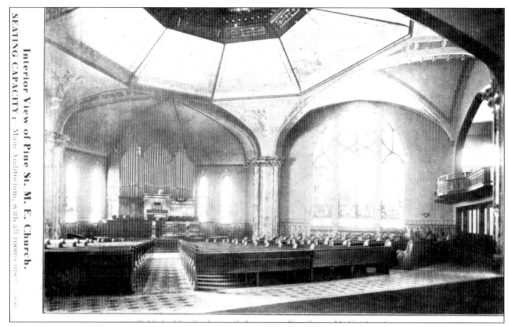

The Interior of the Pine Street Methodist Episcopal Church is captured in time by this vintage postcard. It was built as the fourth-generation home in 1910 on the same site, the northwest corner of Pine and Edwin Streets, and seated 1,000. In 1906, there were 950 members and 800 scholars under the care of Rev. Emory M. Stevens. (Stetts-Maietta collection.)

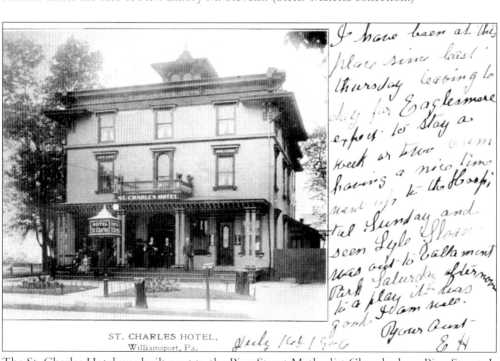

ST. CHARLES HOTEL,
Williamsport, Pa.

The St. Charles Hotel was built next to the Pine Street Methodist Church along Pine Street. It was one of the former sites of the Williamsport Hospital as well as being originally built as the residence of James Armstrong. (Private collection.)

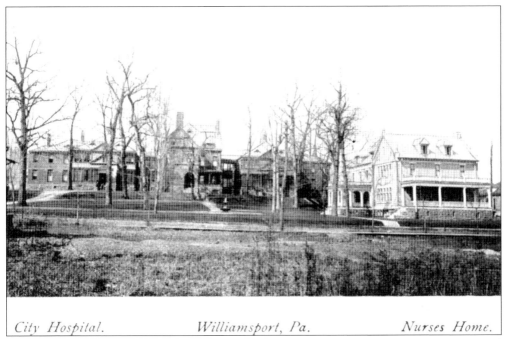

City Hospital. Williamsport, Pa. Nurses Home.

Williamsport Hospital moved up to higher ground after the Flood of 1889, building along Campbell and Louisa Streets where it again, in 2006, is expanding in the same location. (Kane collection.)

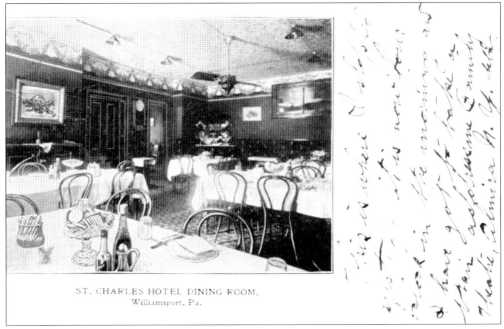

A rare peek at the Victorian Era dining experience for travelers is shown in this St. Charles Hotel postcard. (Springman collection.)

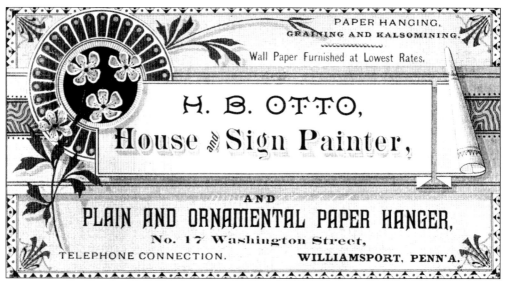

H. B. Otto, who lived and worked from 17 Washington Street (Boulevard now), offered this colorful and ornate Victorian-stylized trade card to customers for their business and residence needs. (Will Fluman collection.)

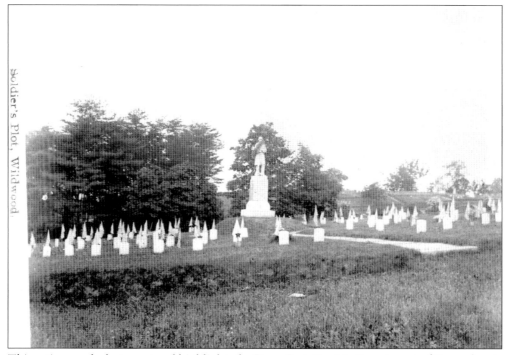

This antique real-photo postcard highlights the Reno Post No. 64, Department of Pennsylvania GAR, and the Veterans Corps of Company G., 12th Regiment's 1886 memorial in Wildwood Cemetery. It stands as "a tribute to the Defenders of the Republic" (1861–1865) where "heroism and patriotism inspired them to deeds of valor." (Will Fluman collection.)

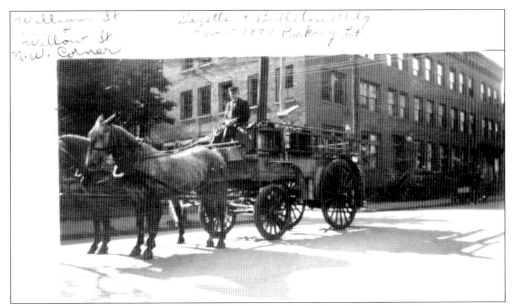

The *Gazette and Bulletin* was one of several newspapers in Williamsport, being located directly behind the *GRIT* newspaper building at the corner of William and Court Streets. (Fagnano collection.)

Shown is the framework for the Williamsport Gas Works along Mulberry Street. The gas works was incorporated on February 7, 1856, with the aim to supply gaslight in the city and vicinity to private businesses and homes. (Thad Meckley collection.)

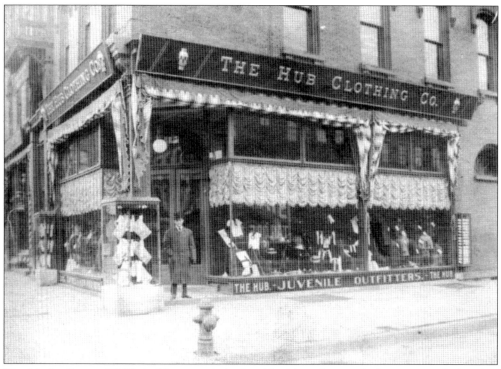

The Market Square HUB clothing store is depicted in this antique real-photo postcard, showing perhaps its owner as he stands proudly in front. (Thad Meckley collection.)

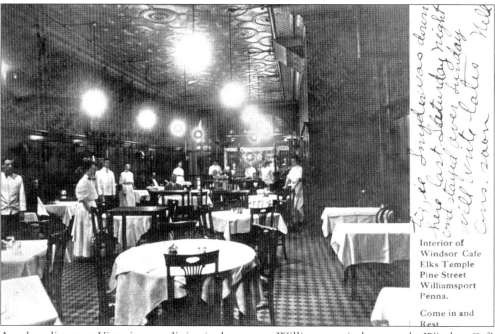

Another glimpse at Victorian-era dining in downtown Williamsport is shown at the Windsor Café in this Elks building next to the Updegraff Hotel on Pine Street. (DiBartolomeo collection.)

Four

WILLIAMSPORT DICKINSON SEMINARY (LYCOMING COLLEGE)

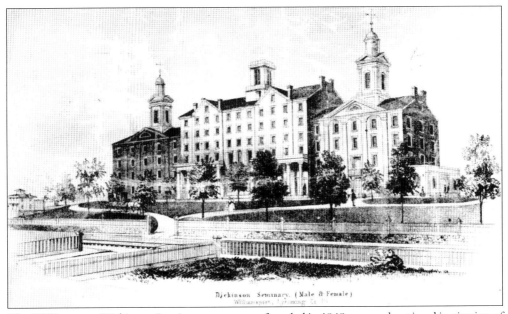

Dickinson Seminary. (Male & Female)
Williamsport, Lycoming Co. Pa.

The Williamsport Dickinson Seminary proper was founded in 1848 as a coeducational institution of higher education by the Methodist church. It later absorbed the facilities of the failed Williamsport Academy around 1830, claiming its founding in 1812 as its own. Later Williamsport Dickinson Seminary became known as Lycoming College. Pictured is the "Old Main" of the campus. (Taber Museum Collection.)

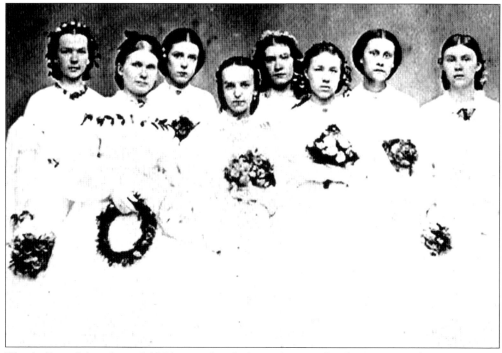

The ladies of the class of 1864 pose for their seminary school picture in this captivating real-photo postcard. (Lycoming College Archives.)

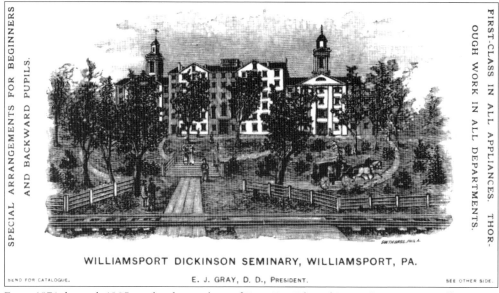

From 1874 through 1905, under the tutelage of Pres. Dr. Edward James Gray, D.D., Williamsport Dickinson Seminary grew into one of the finest of preparatory institutions that money could buy. Gray was married to Eva V. Emery of Williamsport, on December 26, 1861. (Will Fluman collection.)

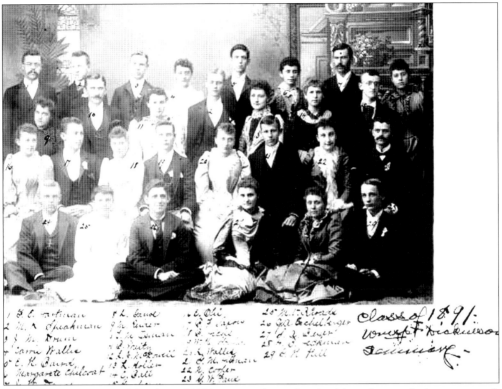

The men and women of the class of 1891 present themselves in this antique real-photo postcard. Their names are included. (Lycoming College Archives.)

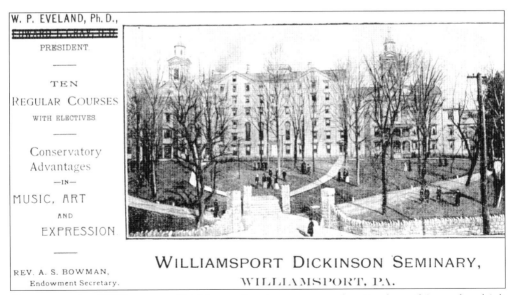

Courses at the Williamsport Dickinson Seminary were advertised on this card, which denoted the changing of the guard as President W. P. Eveland, Ph.D., took over in 1905. (DiBartolomeo collection.)

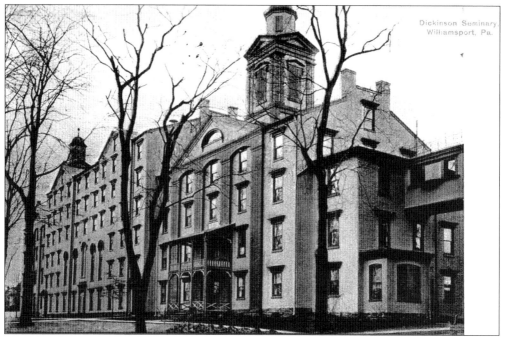

Two hundred and twelve students attended Williamsport Dickinson Seminary on its opening day on September 14, 1848. A three-year course of study was offered for the average going rate of $20 per quarter. In 1860, the seminary changed its name to Williamsport Dickinson Seminary and the second Methodist Episcopal Church was formed in the seminary chapel in Old Main. (Thad Meckley collection)

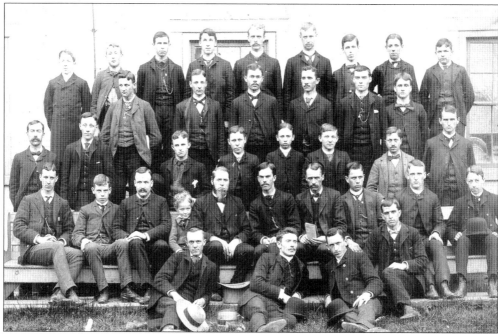

This engaging image is of a men's group at the Williamsport Dickinson Seminary around 1890. (Lycoming College Archives.)

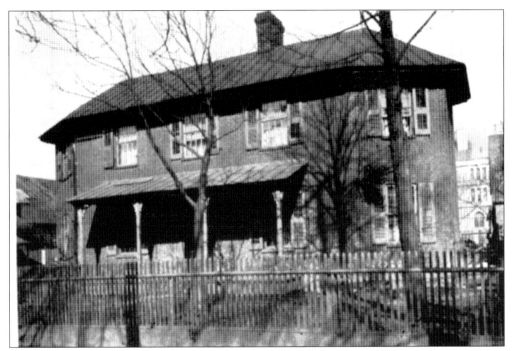

Lycoming College dates its birth back to 1812 from that of the former Old Academy, located on West Third Street near West Street. Williamsport Dickinson Seminary absorbed the school after it was closed and sold off to John B. Hall, who then made his home here. The "Williamsport Academy for the Education of Youth in the English and other Languages, in the Useful Arts, Sciences and Literature" was incorporated April 2, 1811. (Thad Meckley collection.)

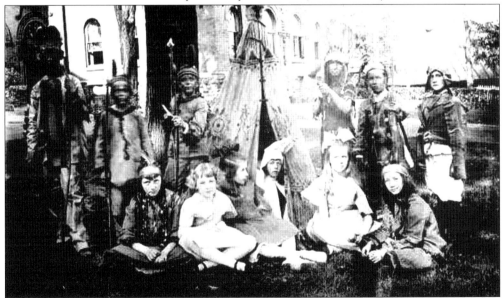

The seminary had a primary school until it became a junior college in 1929. Seen here is a real–photo postcard of area children who attended around 1916. They are listed on the back as Shephard, (Robert) Bell, (Harriet) Pace, (Elizabeth) Hogg, Walsh, (John) Donaldson, (Moylan) Greenfield, (Josephine) Jackson, (Rebecca) Tyndell, (Joan) Stearns, (Florence) McCauley. (Lycoming College Archives.)

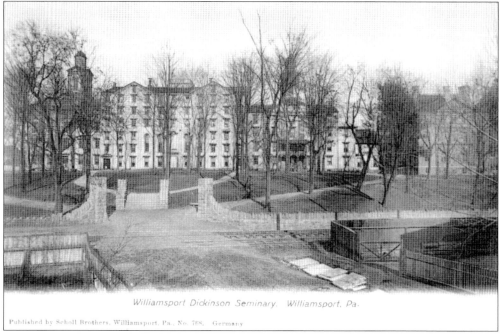

Williamsport Dickinson Seminary. Williamsport, Pa.

Published by Scholl Brothers, Williamsport, Pa., No. 768. Germany

Old Main started out as two buildings, which were later joined in 1854–1855 by a six-story center section, costing $45,575. The west wing was the first part built in 1848 after academy trustees used the sale proceeds of the defunct "Old Academy" to buy one and three–quarter acres where they built their new school building, which was a 40-by-60-foot, three-story brick structure. The east wing came in 1850. (Thad Meckley collection.)

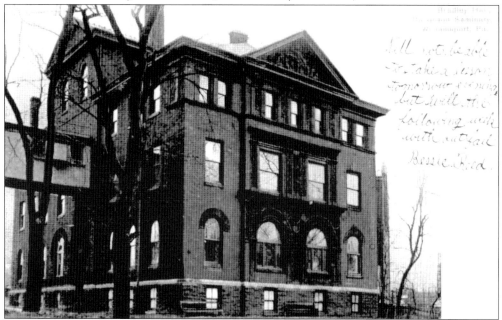

Designed to house the seminary's Conservatory of Music and Arts, Bradley Hall was built in 1895 and named after benefactor and trustee the Honorable Thomas Bradley of Philadelphia. Built by W. H. C. Huffman and Sons of Williamsport, the structure cost $18,600. (Springman collection.)

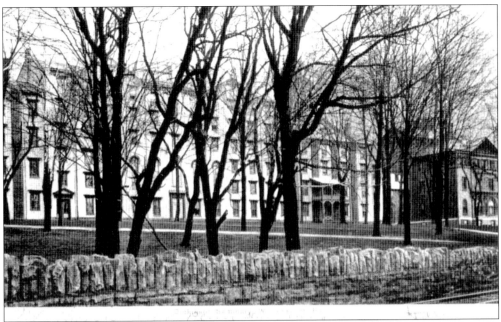

"No she is not Pennsylvania," writes seminary student "Harry" on this vintage Old Main postcard to Edna C. Rockey of 50 College Avenue, York, Pennsylvania, in 1907. (DiBartolomeo collection.)

Old Main was renovated in 1888 with 81 apartments that were painted followed by further upgrades such as electricity two years later. The grand dame Old Main was demolished during the Christmas break of 1968–1969, taking two weeks to bring the massive landmark to the ground. Lamade Gymnasium sits on the former site. (Springman collection.)

A couple of Williamsport Dickinson Seminary (WDS) students pose for this real-photo postcard for a friend, writing, "A reminder of 'Chestnut Party Day' and the fun you missed. Esther" School records do not record when the event actually began or ended, but accounts recall "searching for chestnuts or engaging in some other amusement, such as playing 'duck and drake,' or roasting the chestnuts . . . gathered." (Thad Meckley collection.)

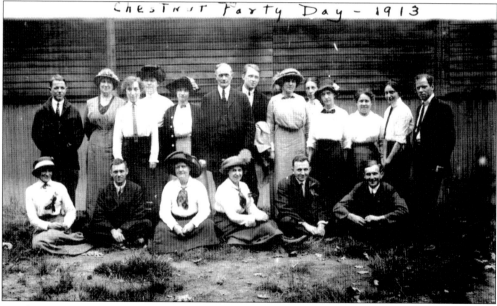

Faculty and staff pose during the 1913 annual "Chestnut Party Day" fall celebration when the school created its own holiday as an excuse for a needed break from classes each October. In the center of the real-photo postcard is the WDS president, the Reverend Dr. B. C. Conner (from 1913 through 1921), who also taught at the seminary in his younger days before returning at age 63 to take charge. (Daniel Bower collection.)

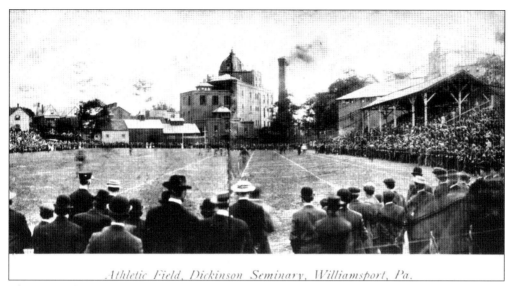

This unusual 1908 postcard view captures the Williamsport Dickinson Seminary football team in action during a home game before a packed house of fans. (Sprunger collection.)

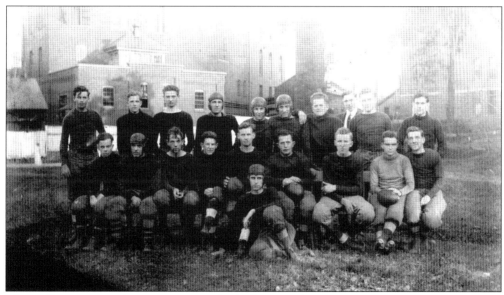

The Williamsport Dickinson Seminary football squad of 1914 poses in this real-photo postcard at the end of their home field with the Flock Brewery in the background. The team roster was as follows: Burgess, Bastian, Barringer, Black, Cherry, Corbett, Collier, Haskins, Kline, Knox, Karns, Krebs, Meyers, Mackie, Little, White, Williams, and Young. The team was coached by Jackson M. Painter. (Sprunger collection.)

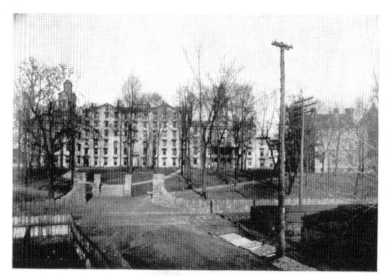

It's *got* to be, and it's *goin'* to be!
So at least I will just try
To promptly say in a hearty way,—
"Well, it's *got* to be, Aye! Aye!"

Adapted from James Whitcomb Riley and dedicated to the
friends of the Endowment. With Best Wishes,

Sincerely yours,

Williamsport Dickinson Seminary, Williamsport, Pa.

Williamsport Dickinson Seminary operated as a private preparatory boarding school until 1929 when it became the Williamsport Dickinson Junior College, Pennsylvania's first. Next the college name changed to Lycoming College in 1947, when it became a four-year degree liberal arts college. (DiBartolomeo collection.)

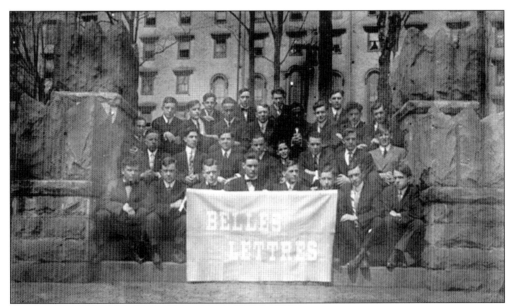

Belles Lettres was one of three literary societies on campus with the Gamma Epsilon and the Tripartite Union being the others. The first two were in the gentlemen's department and the latter in the ladies' with all preparing and reading a paper in the chapel once every three weeks. Each had its own hall with a well-stocked library to do research. (Thad Meckley collection.)

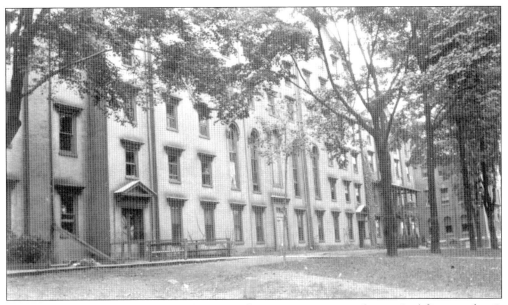

The east wing of Old Main was built in 1849 for $8,500 upon a newly acquired five-acre lot. It was three stories high and measured 40 by 70 feet. (Thad Meckley collection.)

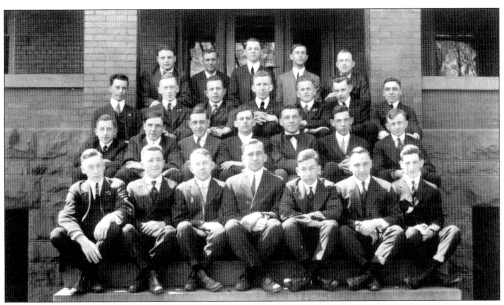

The Theta Pi Pi fraternity in 1915 is immortalized in the real-photo postcard, given by "Jonies." The partial list of names included, from left to right, are as follows: (first row) B. Forcey, Buck, unidentified, Nearhoff, Punk Keatley, Harold Hess, and Patterson; (second row) F. Hill, Krebs, H. Dodson, and four unidentified men; (third row) unidentified, Forcey, H. Jones, W. Lewis, and three unidentified men; (fourth row) Professor Oppenhiem, Professor Jefferies, Professor Frank, Professor Fisher, and Professor Pearl. (DiBartolomeo collection.)

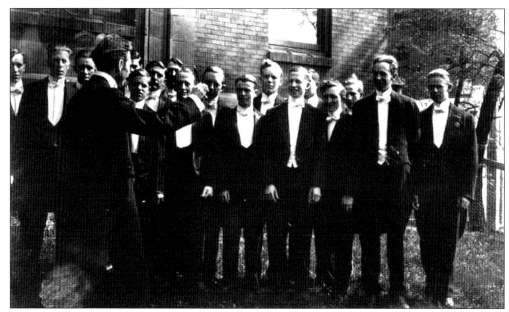

The 1912 glee club sings under the direction of Williamsport Dickinson Seminary music instructor Dr. Will George Butler, who taught from 1904 until 1914, when he left to take a position at his alma mater, Mansfield State College, remaining there until 1938. A musician and composer, Butler wrote the school song, "Fair Dickinson," as part of his legacy at the seminary. (Lycoming College Archives.)

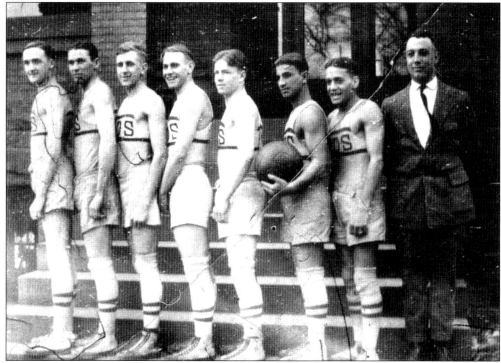

A Williamsport Dickinson Seminary basketball team from the second decade of the 20th century is pictured in this real–photo postcard sporting postcard. (Lycoming College Archives.)

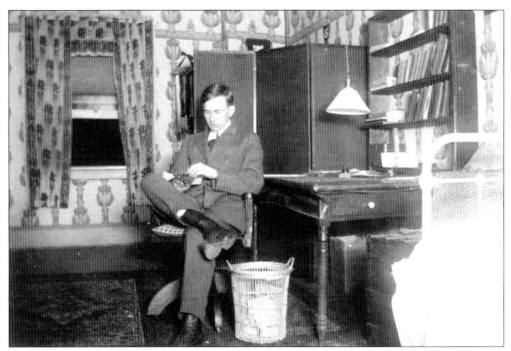

A real-photo postcard from the Lycoming Archives portrays Williamsport Dickinson Seminary professor Elna H. Nelson, who taught Latin and mathematics, in campus quarters. Faculty and students alike roomed on campus together in the Old Main building. (Above, Lycoming College archives; below, DiBartolomeo collection.)

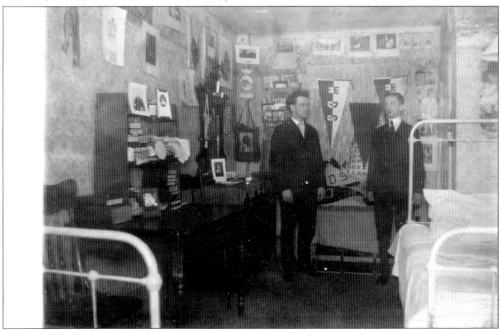

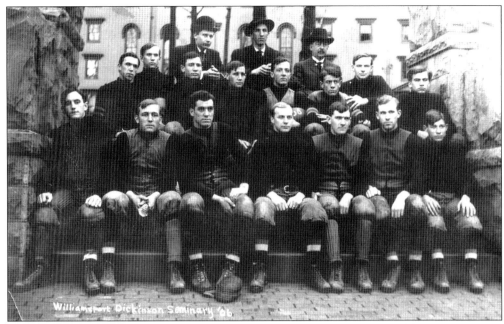

While Williamsport celebrated its centennial, the seminary football team celebrated a winning season of their own. Shown is an amazing real–photo postcard of the victorious group under captain Rothfuss in 1906, going 7-2 and losing only to Mansfield Normal and the Carlisle Indian Reserves. (Lycoming College Archives.)

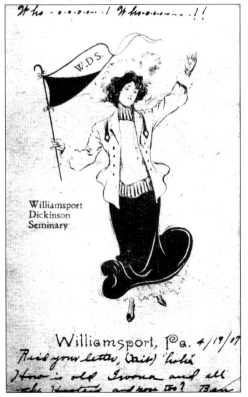

"Ms. Williamsport Dickinson Seminary" is one of a series of college schoolgirl postcards published by Cunningham Publishing of Williamsport. This and all her "relatives" don wardrobes in their school colors. The card was addressed to Byrd Morgret of Irvona in Clearfield Company, Pennsylvania. (Joseph Epler collection.)

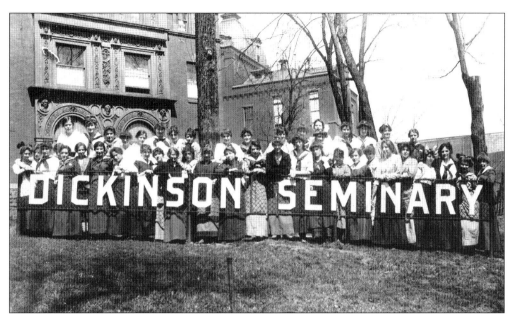

Terra-cotta pieces of Bradley Hall's exterior, which cost $1,200 in 1895 plus the cost of moving from the train car to the site, were saved and repositioned in the Mary Welch Honors Hall interior in 2005. (Lycoming College Archives.)

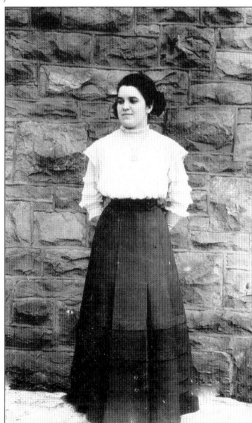

Addressed to Henrietta Tull, the April 14, 1908, card reads: "Never forget how we studied Carlyle's essay on Burns for the examination at the close of Winter Term 1908. We left for vacation on the same train. Your Loving classmate, Sarah R. Mills." (Lycoming College Archives.)

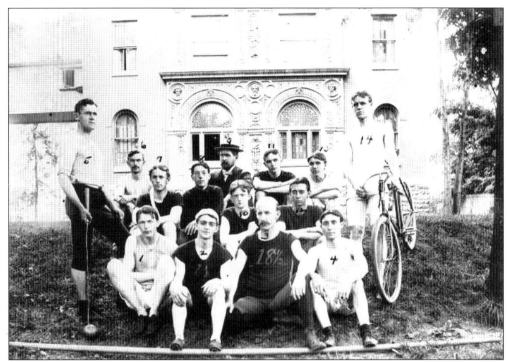

The 1897 track and field team of Williamsport Dickinson Seminary poses with identification numbers penned in and long jump statistics marked up as well. They are posing before Bradley Hall, which was tragically demolished in 1890. (Lycoming College Archives.)

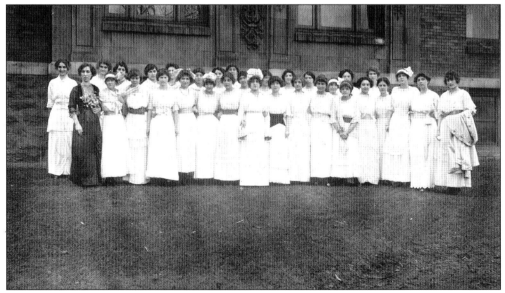

In 1860, a new rule was added to the by-laws, "The ladies and Gentlemen must not visit each others' apartment, walk, or ride together, without permission; nor converse together from the windows," and the rule did not permit "slight association in the recitation-room, at the table, and in the public exercise in the Chapel." (Lycoming College Archives.)

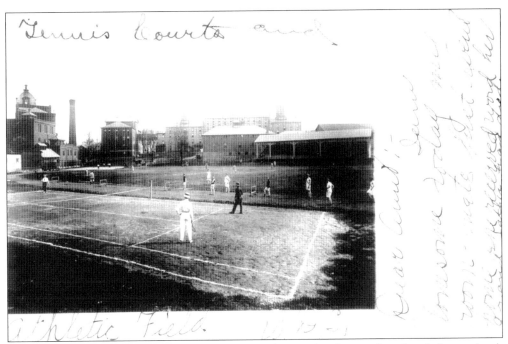

Tennis anyone? Students at the Williamsport Dickinson Seminary take a break from school, playing a game of tennis on the school's athletic fields. In the background to the left of Old Main and Bradley Hall is the massive Flock Brewery plant (also known as the former City Lager Beer Brewery), located at 601 to 625 Franklin Street, which was designed by Philadelphia architect A. C. Wagner. (Sprunger collection.)

The end of an era came on Friday, August 10, 1951, as Flock Brewery stockholders sold the real estate and personal property at 601 Franklin Street to Lycoming College for future school expansion. The factory was later demolished, and the home of W. E. Flock, brew master, was used as a fraternity. (Thad Meckley collection.)

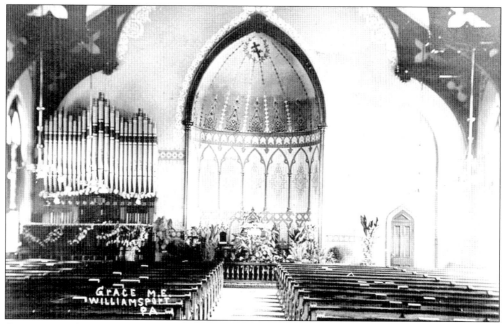

Grace United Methodist Church is one of several area churches associated with Lycoming College with its longtime dean, the Reverend John Piper, having served as its pastor for many years. The author owns the church parsonage, which was built by the famous Reverend Silas C. Swallow in 1886. (Private collection.)

St. Boniface Church, located at 322 and 324 Washington Boulevard, was built 1873–1875, replacing the former church built there in 1855 for its German Catholic parishioners, including some Seminary students. Mulberry Street Methodist was the official seminary church although St. Boniface and Pine Street Methodist were also used by seminary students and faculty. This stone edifice burned in December 1973 during a series of arson fires of area churches. (DiBartolomeo collection.)

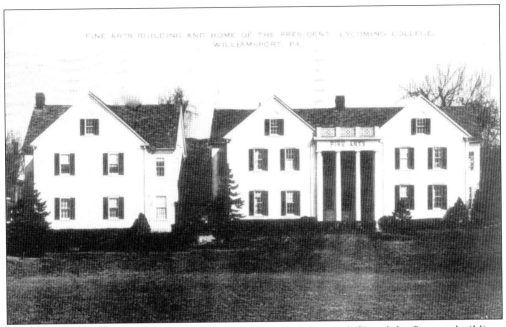

This unique vintage postcard captures both the president's house (left) and the fine arts building, which was actually two homes connected in 1941 that were said to be formerly owned and built in the 1870s by local merchant L. L. Stearns. This connected-pair structure was torn down in 1986. (Thad Meckley collection.)

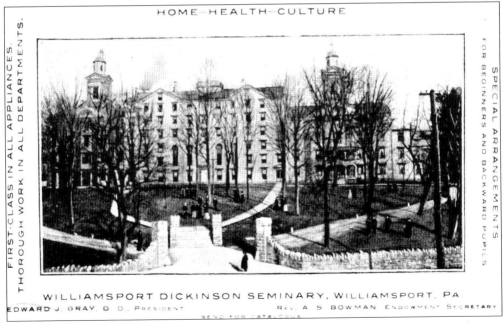

"Home-Health-Culture" was the promoted special features of the Williamsport Dickinson Seminary as seen here on this advertising postcard. (Fagnano collection.)

While a high school was not formally established in Williamsport until 1869, by 1878, one was in session on the third floor of the Curtin School Building, located at 612 Market Street, on the point of Market and Packer Streets (site of the First EUB Church) pictured here through the trees. Formerly the students met on the second floor of the Engine House No. 1 on Mulberry Street. (Stetts–Maietta collection.)

"Ms. Williamsport" is one of a series of Pennsylvania high school girl postcards published by Cunningham Publishing, of Williamsport. This and all her "relatives" don wardrobes in their school colors. (Joseph Epler collection.)

Five

BRANDON

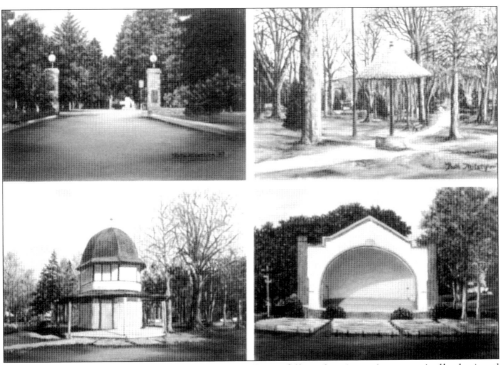

Brandon Park through the seasons—summer, winter, fall, and spring—is romantically depicted in this rare colorful postcard through the four original artwork paintings of Williamsport artist Ruth Mitstifer. (Michelle Kaiser-Webb collection.)

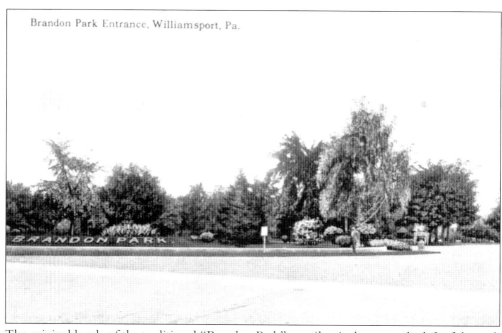

The original locale of the traditional "Brandon Park" moniker is shown to the left of the park entry. Years later, the Brandon Park committee has recreated this landscaping and visual delight to the right of the entryway using English boxwood. (Kane collection.)

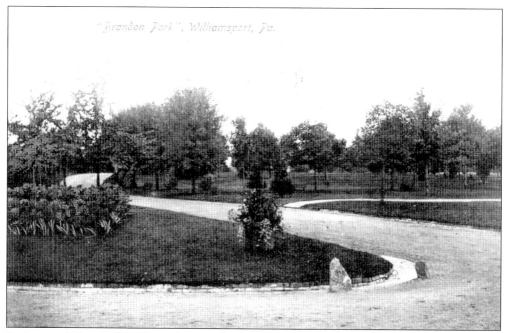

In August 1894, the Brandon Commission approved the purchase of 400 sugar and Norway maples, adding to "the large number of thriving young trees" growing in the park. These new trees replaced those that died as well filling out the park drives along which trees were not yet planted. (Kane collection.)

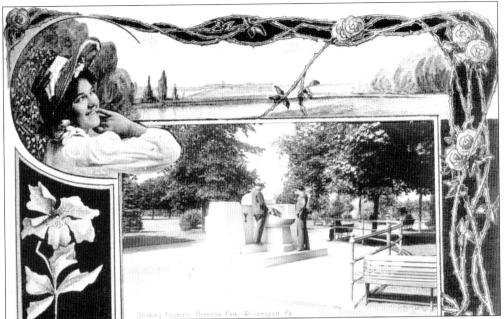

The *Gazette and Bulletin* announced on June 26, 1901, the unveiling of O. H. Reighard Memorial Fountain to be dedicated on July 1 to the park commission president. The Honorable Oliver H. Reighard (state legislator) lived at nearby 330 Mulberry Street while he practiced law in downtown Williamsport. Mrs. Reighard was the former Lizzie Gamble, daughter of neighbors Judge and Mrs. James Gamble, who were betrothed on January 1, 1885. Their namesake son was James Gamble Reighard. (Carson collection.)

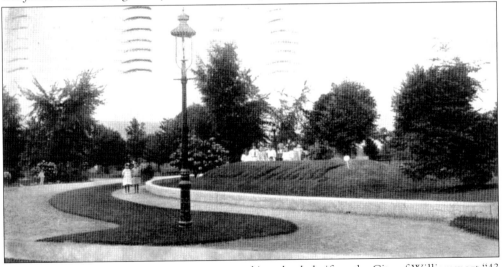

In February 1889, A. Boyd Cummings conveyed in a deeded gift to the City of Williamsport "43 acres and 39 perches of land in trust for the purpose of a park for public use," requesting it to be known as Brandon Park. This was in honor of the memory of his late sister Jane Cummings Brandon, 34, who inherited it from her brother John Cummings Jr. upon his death. Upon the passing of John Brandon and Jane Brandon (née Cummings), their next of kin, Jane's brothers—Alexander, Thomas, and Andrew Boyd—were vested interest in the land, of which was conveyed full interest to A. Boyd in August 1864 and May 1884 respectively. (Springman collection.)

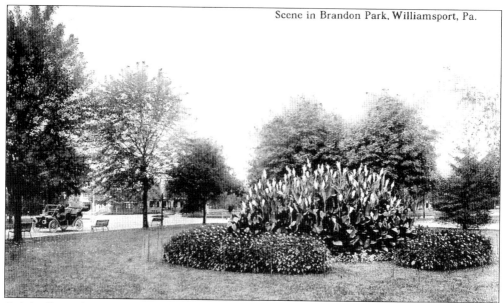

Scene in Brandon Park, Williamsport, Pa.

Originally in the proceedings of the Orphan's Court of Lycoming for the partition of the real estate of Michael Ross, recently deceased, and under an injunction thereof taken December 4, 1820, by the high sheriff of Lycoming County, the park parcel was "allotted and adjusted to James H. Huling and in the right of his wife, Margaret, one of the daughters of the said Michael Ross, on December 5, 1823." They consigned it to Espy Van Horn Esq., on May 15, 1824, as part of a deal by John Ross, Peter Vanderbelt Jr., and James H. Huling, administrators of the estate of Ross in pursuance of an order of the said Orphan's Court. Espy Van Horn and his wife conveyed it to John Cummings Jr. then on November 25, 1825. (Springman collection.)

When Brandon Park was first gifted, it was noted that "if laid out for building lots it would realize $80,000." And while the park has not ever seen any residents long-term, a youthful Brandon was used briefly after the June 1889 Flood disaster as a tent city for flood victims as of June 7. (Thad Meckley collection.)

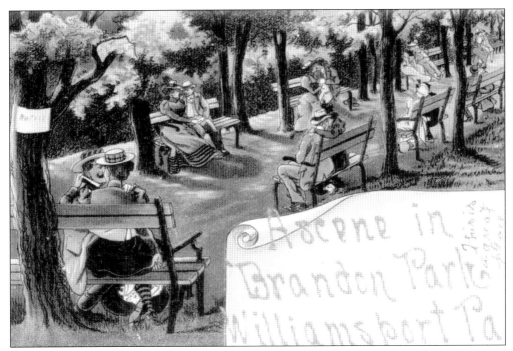

The Brandon Park Commission's first members included commissioners J. Artley Beeber, John F. Laedlein, Lindsay Mahaffey, John G. Reading, William G. Elliott and the Honorable O. H. Reighard (president), and Mayor James S. Foresman. (Daniel Bower collection.)

The first commission made a "special request of Council" for funding to lay flagstone sidewalks along the southern side of the park. With its "available means at its command," they had the drives (North, Middle, and South, respectively) and walks placed in "something like permanent condition," covering them with red shale in hopes of a good hard surface. (Thad Meckley collection.)

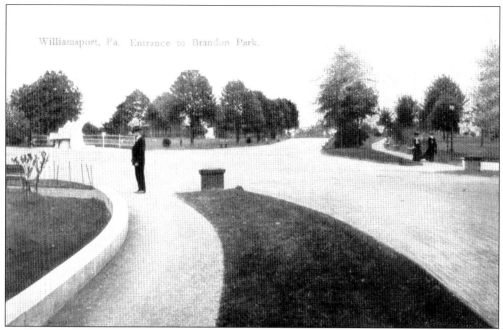

Brandon Park was originally laid out by engineer and lumberman Robert Faries, but his plans were later taken up by a Mr. Nielson, who had railroad engineers change some features before presenting to the Common and Select councils, which both adopted them. There were such features as tennis courts, baseball diamonds, and swings in the park, coming before a regularly supervised playground was considered. (Thad Meckley collection.)

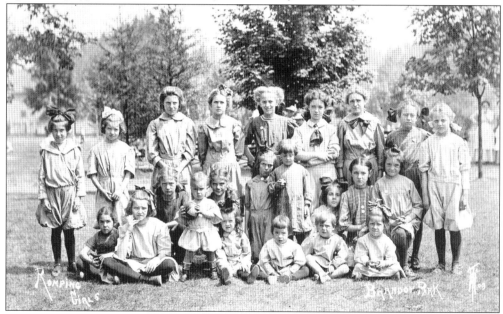

This real-photo postcard captures the "Romping Girls" of Brandon Park. No identifications or details of this youth title can be found to date. However one can only imagine the surprise of these little ladies if they knew then of this modern-day featured display for generations to share in their glory and fun. (Thad Meckley collection.)

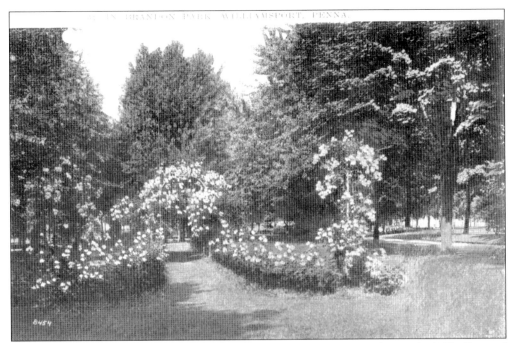

Rose trees from Germany were presented on May 6, 1907, to Brandon Park. Still alive and blooming in 2006, the rose garden has long been a favorite site for park visitors since its inception. (Thad Meckley collection.)

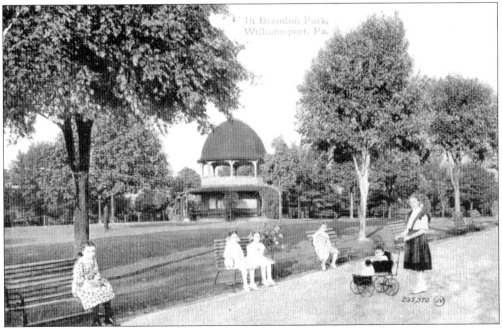

This common local postcard actually depicts family and friends of its owner. The little girl in the white frock is her mother, Lola Reese Spangle, and the girl pushing a family friend in the baby buggy is her aunt, Dorothy Reese. Sadly, the author missed meeting the famed "Lola Rae" by some six months after her passing at 104 years old. (Reese Family collection.)

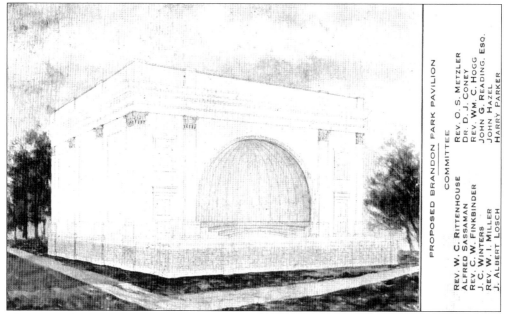

This extremely rare promotional postcard from the *Gazette and Bulletin* newspaper shows the proposed band shell design plans that never materialized. The "Pavilion" project fund-raising effort was launched on July 8, 1912, and was completed by August 5, 1912. (Thad Meckley collection.)

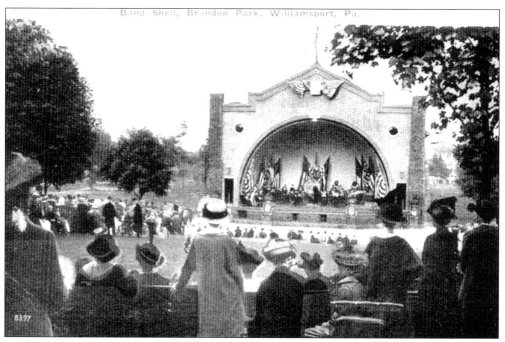

The Brandon Park band shell was dedicated on June 17, 1914. This colorful postcard commemorates the actual scene with the festive red, white, and blue regalia that draped the new edifice in full glory. Ladies that flocked to the event with stylish hats and fashions of the day are seen enjoying the day's event. (Thad Meckley collection.)

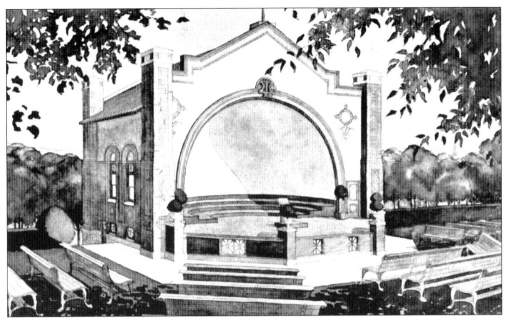

This illustrative postcard shows a watercolor rendering of the proposed Brandon Park band shell, which still stands and is used over 100 years later in 2006 for "open-air concerts," as music was a frequent guest request by its donor, A. Boyd Cummings. The first such performance in the park setting itself was in 1899 and then later the famed Repasz Band christened the newly built band shell in 1914 before a crowd of 8,000. (Fullmer collection.)

WILLIAMSPORT, PA., .. 1913

I HEREWITH SUBSCRIBE

.. DOLLARS

FOR THE PROPOSED OPEN AIR PAVILION IN BRANDON PARK
PAYABLE ON DEMAND

NAME..

ADDRESS..

COMMITTEE

REV. W. C. RITTENHOUSE	REV. W. I. MILLER	REV. WM. C. HOGG
ALFRED SASSAMAN	J. ALBERT LOSCH	JOHN G. READING, ESQ.
REV. C. I. RAFFENSPERGER	REV. O. S. METZLER	JOHN HAZEL
J. C. WINTERS	DR. J. D. CONEY	HARRY PARKER

F. ARTHUR RIANHARD, ARCHITECT

The 1913 band shell–rendering postcard back shows this to be a promotional fund raising solicitation. The committee working on the campaign drive is listed as well as its architect and native son, Franklin Arthur Rainhard. Rainhard was the son of George W. Rainhard, who helped start the Pennsylvania *GRIT* newspaper, serving first as job department manager and later its editor until July 1, 1892. (Fullmer collection.)

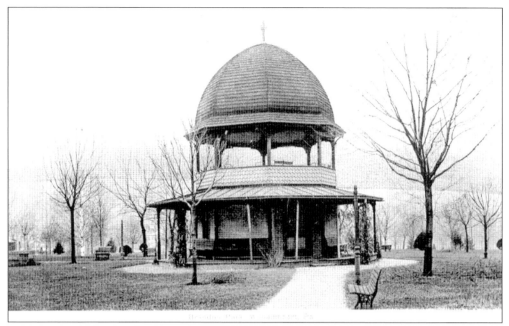

Early on, park commissioners met to discuss at length facts that the lack of funds during its initial year would hamper the development of the park. Likewise, newspaper accounts tell that "the Commission is alive to the importance of beautifying the park, and is only hampered in the work by the inadequate appropriation at its command." (Thad Meckley collection.)

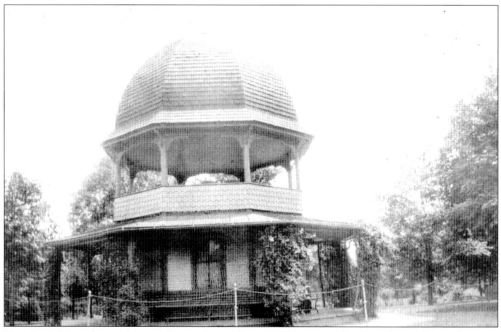

Brandon's Victorian-style roundhouse is a park and Williamsport landmark, surviving the years with much dignity despite much of its gingerbread details being removed or covered over. This real-photo postcard shows the structure soon after it was built. (Kane collection.)

Six

GRAMPIAN

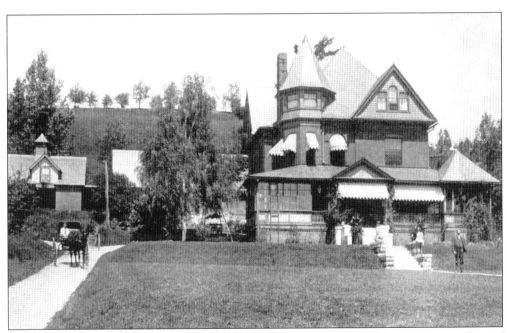

This real-photo postcard showcases the Huffman family, the original owners, proudly in front of their spectacular 1896 Victorian mansion at 225 Grampian Boulevard soon after their homestead was built. William H. C. Huffman was Williamsport's leading builder during the late Victorian era, operating W. C. Huffman and Sons Builders on West Third Street. This rare card has been passed down through the home's owners for generations and is proudly cared for by current owners Jim and Karen Myers. (Myers collection.)

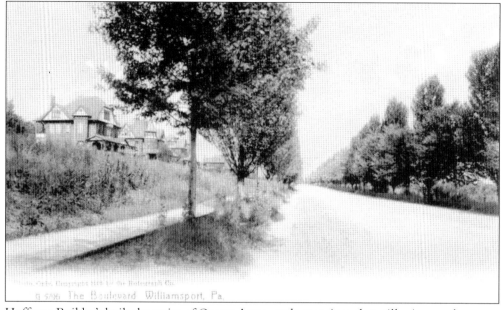

Huffman Builder's built the series of Queen Anne–style mansions that still reign on the upper side of lower Grampian Boulevard in 2006. Addresses along the grand thoroughfare list the names of Williamsport's elite businessmen and families of the day: Otto, Schleh, Thrall, Moltz, Reilly, Reese, Mitchell, and Stuart. (Myers collection.)

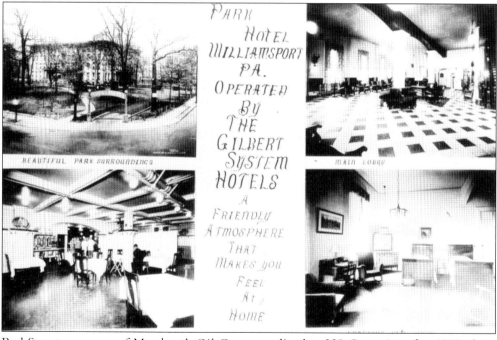

Bud Stuart, manager of Merchant's Oil Company, lived at 229 Grampian after 1900 along with his mother, Laura V. Stuart, in whose honor he founded the famed and grand Park Home (formerly the Park Hotel at 800 West Fourth Street) for elderly women. Mary T. Stuart also lived there while working as a music instructor at the nearby Williamsport Dickinson Seminary. (Private collection.)

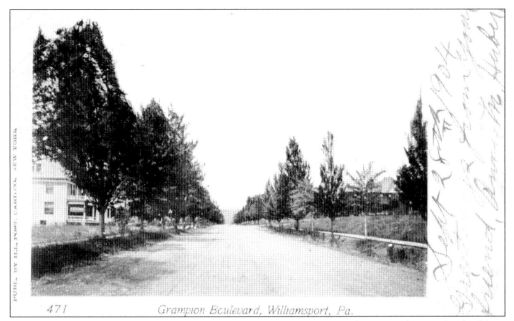

The Honorable Max L. Mitchell and family moved from his 504 Park Avenue home after building his *c.* 1905 Colonial Revival showplace (left). Mitchell was a local attorney at 19 West Third Street and a judge, serving from 1900 until 1902, as president judge of Lycoming County. Mitchell not only graduated head of the class in 1855 from the Williamsport Dickinson Seminary where his father served as college president, but he was actually born there on January 23, 1866. In 1887, he took top honors as a Dickinson College (Carlisle, Pennsylvania) graduate. (Kane collection.)

Alfred D. Huffman, son of W. H. C. Huffman, lived at 411 Grampian Boulevard in 1905 while working at the family business (W. H. C. Huffman and Sons) with brother John E. D. Huffman, who lived at 234 West Third Street. In 1912, their widowed mother, Lena, lived with son Alfred at 411, having moved out of 225 Grampian, which became occupied by the Frank B. Thrall family. The Thrall's operated their wholesale grocery business (F. B. Thrall Company, Inc.) at 301 West Third Street. (Springman collection.)

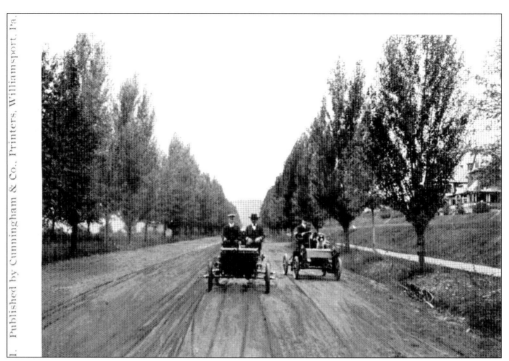

The Dr. Koser Hospital, Williamsport, Pa.

Early motorcars were a common sight on Grampian, a favorite spot for Williamsport's elite to tour up and down the fashionable strand on a Sunday afternoon. (Thad Meckley collection.)

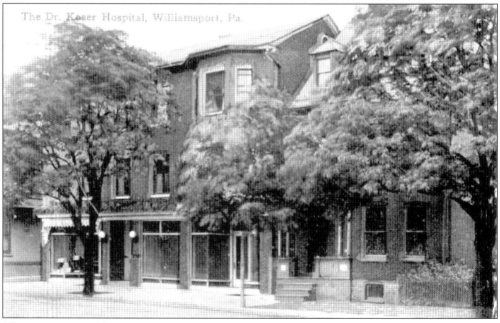

The Koser Hospital was a private sanitarium institution at 426–428 Market Street, being run by Drs. S. S. and C. Williamee Koser, physicians and surgeons, who lived at 415 Grampian Boulevard. S. S. Koser had commenced his practice upon graduating in 1873 from the University of Pennsylvania in Schuykill County. Afterwards he studied in Europe before settling in Williamsport in 1882. (Thad Meckley collection.)

Grampian Boulevard was originally called Grampian Drive, being located beyond city limits for the most part. In 1900, Grampian was listed finally in the city directory and noted as running east from 1800 Packer to Almond Street, being just shy of the Poco Farm Estate at 229 Grampian. (Will Fluman collection.)

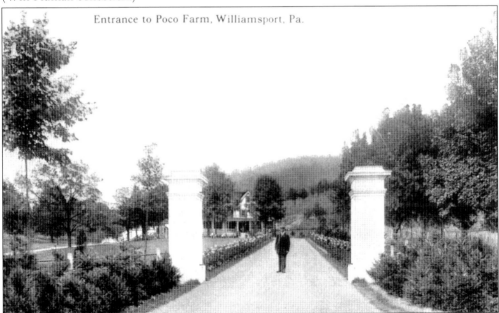

This linen-style postcard tells a tale that the man pictured is "Shaw's daughter's husband, of Philadelphia." The white wood-sided, country estate manor was the former home of this man's deceased father-in-law, Phillip B. Shaw, manager of the Williamsport Steam Company. It tells that the couple came every summer for four months to Poco Farm. "Oh my, how nice," laments the writer. The name Fred Wood appears next to this tale. (Thad Meckley collection.)

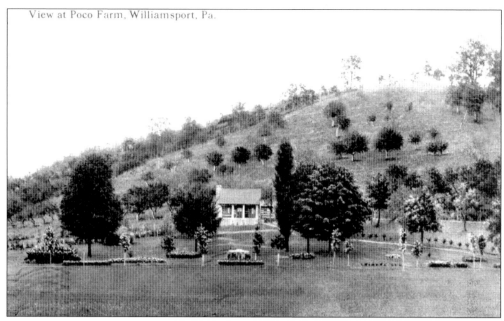

View at Poco Farm, Williamsport, Pa.

Stories passed down tell that the waterfalls next to the main Poco Farm house were used to generate electricity for a series of lights on poles that encircled the entire sprawling estate, which has since been carved up into dozens of plots. "This driveway is all around the place and it is kept just as clean as a pin. Oh, it's grand." The name Arzy Wood appears next to this tale. (Thad Meckley collection.)

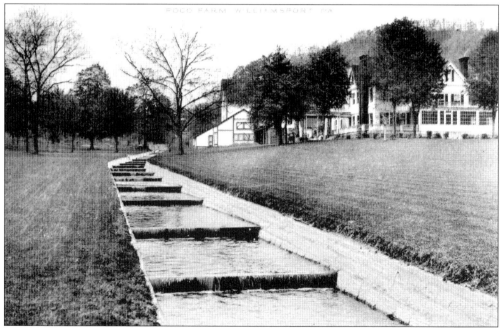

The Poco Farm at 929 Grampian Boulevard was elegantly restored by former owners Kent and Patricia Baldwin in the 1980s before falling back into disrepair years later. In 2005, the stately country-Victorian style mansion was rescued from certain demise and is being refurbished in 2006. (Thad Meckley collection.)

Seven

LUMBER DAYS

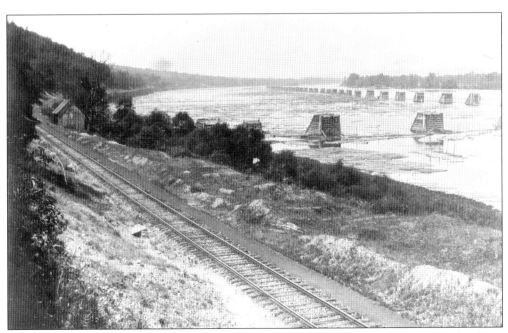

Susquehanna Boom Company was incorporated in March 1846 when Gov. Francis R. Shunk put his seal of approval on the general assembly's legislative act. The owners were Maj. James Perkins (24 shares), John DuBois Jr. (25 shares), Matthias Dubois (25 shares), Issac Smith (20 shares), Elias Lowe (5 shares), and John Leighton (1 share). This rare view shows the boom with its stone pilings which held the fallen logs before they were cut into lumber. (Will Fluman collection.)

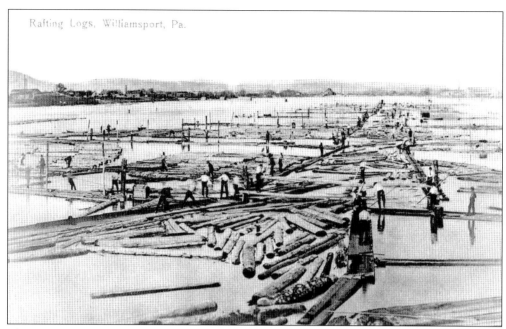

The Susquehanna Boom is shown in full-action as "river-rat" workers sort the logs, spars, and any other floating timber, including driftwood, stopped and stored in the boom. They sorted the logs which used branded symbols, much like cattle are branded, to identify each company's logs. (Will Fluman collection.)

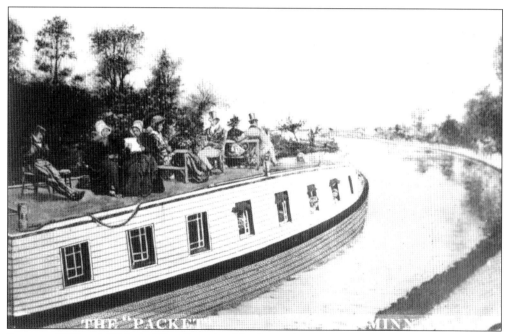

Between 1828 and 1834, the West Branch of the Susquehanna River section of the Pennsylvania Canal was built, opening officially on July 4, 1834. Dignitaries rode the *James Madison* from Northumerland to the end, which was at the mouth of the Loyalsock Creek. They proceeded by stagecoach from there back to Williamsport. (Will Fluman collection.)

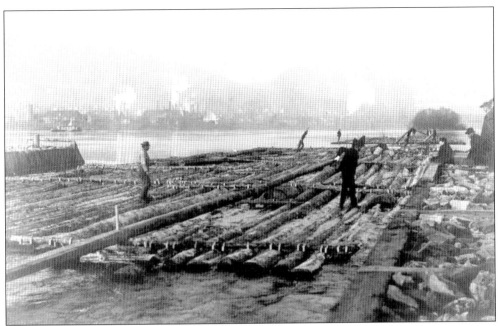

This real-photo postcard shows the Williamsport chute of the Susquehanna River dam at Hepburn Street. At the finish of the run down to the markets downriver, the spars of the rafts were sold off, becoming the masts for the sailing vessels of the Chesapeake Bay ports. The proceeds would pay for their food and transportation home to Williamsport. (Will Fluman collection.)

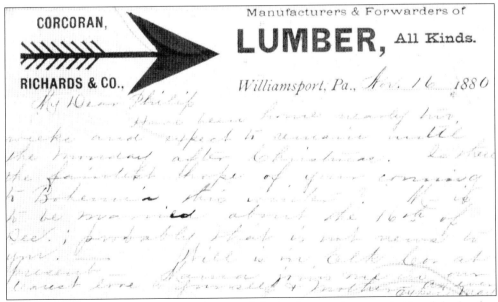

This 1880s lumber postcard give a glimpse of the business and personal side of the lumber trade in 1880. Corcoran, Richards and Company, located at 51 West Third Street, became the Corcoran Lumber Company 10 years later with James Corcoran as president, J. B. Denworth Esq. as secretary, and Harry H. Hill as treasurer. (Thad Meckley collection.)

Fletcher Coleman became the first president of the Lumberman's Exchange in April 1872. Other officers included well-connected lumberman and vice-president Samuel N. Williams, treasurer Eugene R. Payne, and directors Benjamin C. Bowman, Elias Deemer, William Emery, John R. T. Ryan, Henery W. White, and Williams Howard. (Thad Meckley collection.)

This particular lumber trade postcard was written and signed by Williamsport lumber baron and banker Elias Deemer, of Elias Deemer and Company (John H. Hunt), of 327 Pine Street. Deemer built the mansion at 711 West Street, a magnificent Queen Anne–style masterpiece by architect Eber Culver. The mansion has undergone extensive restoration in recent years, bringing it back to its former glory by its current owners. (Thad Meckley collection.)

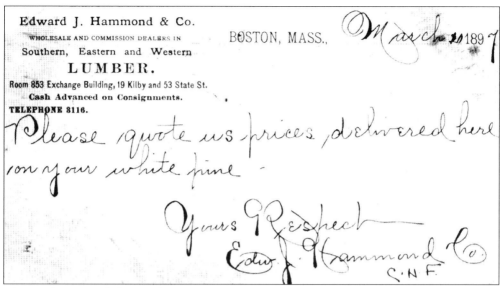

This trade postcard denotes business in March 1897 as E. J. Hammond Lumber of Boston sought prices for Williamsport white pine from lumber magnate Fletcher Coleman. (Thad Meckley collection.)

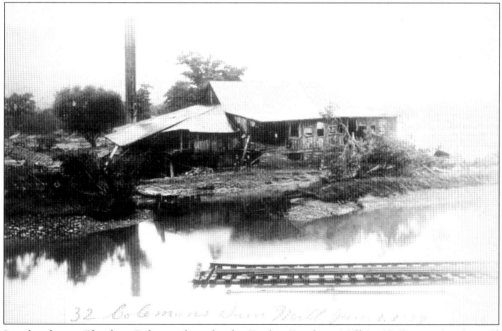

Lumber baron Fletcher Coleman bought the Dodge Brothers Mill in 1863, running it until its close in 1898. Fletcher Coleman built his 1107 West Fourth Street mansion, which was demolished in 1991. Preservation Williamsport activists salvaged parts of the grand structure for reuse before its demise. (Private collection.)

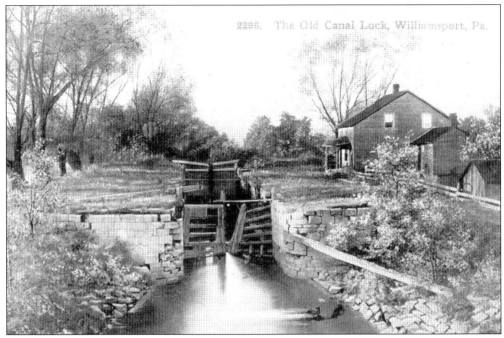

This postcard shows canal lock No. 2 along the local branch of the Pennsylvania Canal, which first brought many of Williamsport's early visitors to the rural West Branch Valley. The canal connected Northumberland to Williamsport in 1833 before connecting to Lock Haven a year later. (Thad Meckley collection.)

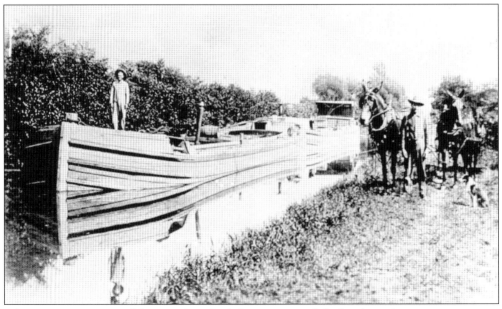

John McMinn, owner of the McMinn Coal Company, used the local canal system to transport his coal and ice business goods. With his acquired wealth, McMinn built a modest residence at 528 West Fourth around 1850. The house was later sold to settle his estate in 1871 upon his death for $12,000 to Benjamin C. Bowman. (Taber Museum Collection.)

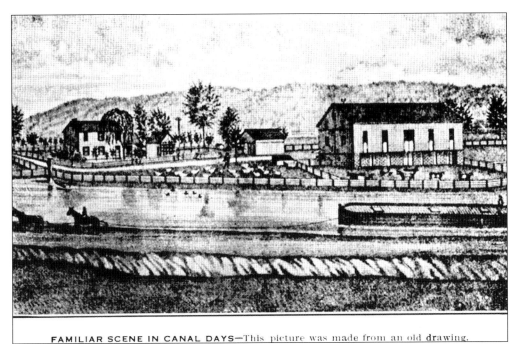

FAMILIAR SCENE IN CANAL DAYS—This picture was made from an old drawing.

Pennsylvania Canal packet boats began passenger travel in 1838, being towed by horses or mules along "tow paths" at the canal's edge. This scene shows a load of finished lumber being sent to market via the canal, whose use was slowed in 1855 by the arrival of the railroads. (Thad Meckley collection.)

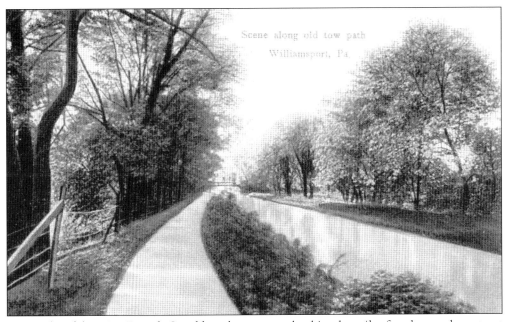

Tow paths of the West Branch Canal later became used as bicycle trails after the canal went out much in the same spirit as railroad track lines are being transformed for the same by Pennsylvania's Rail-to-Trails redevelopment program. (Thad Meckley collection.)

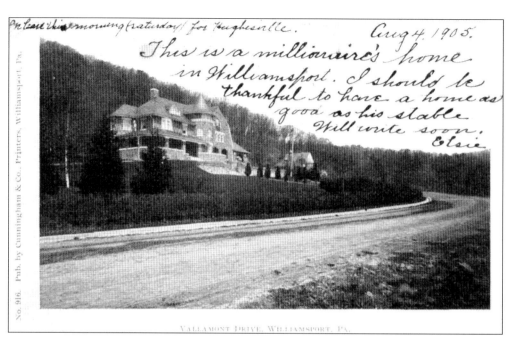

On leave this morning (Saturday) for Hughesville. *Aug 4. 1905.*

This is a millionaire's home in Williamsport. I should be thankful to have a home as good as his stable. Will write soon.
Elsie.

Millionaire Allen Putnam Perley moved to the Greystone mansion, having lived at 309 Campbell Street in the Queen Anne–style mansion he built while amassing his fortune. Perley was partners with William Howard in the Howard and Perley lumber firm, located at the corner of Rose and West Third Streets. (Private collection.)

The Dodge Mill, located in Newberry between Arch Street and the mouth of Lycoming Creek, was the largest Williamsport mill ever built, having five gangs, three single saws with an edger, a lath mill, and a picket mill. William E. Dodge, of New York City, and partners Daniel James and James Stokes owned the mill but did not live in Williamsport. (Private collection.)

Peter Herdic employed lumber workers when times were tough due to logging in the west flooding the market. This is a reprint of an advertisement that he offered to build Williamsport spec homes, which coincidentally were on lots he owned. (Thad Meckley collection.)

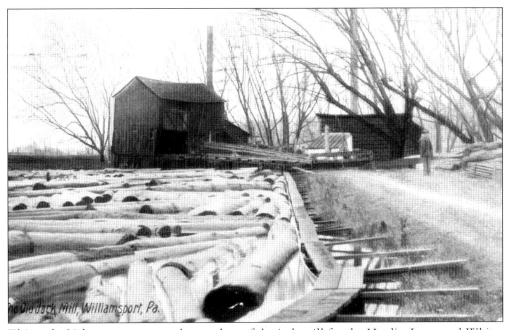

This early 20th-century postcard was taken of the jack mill for the Herdic, Lentz and Whites lumber mill. (Thad Meckley collection.)

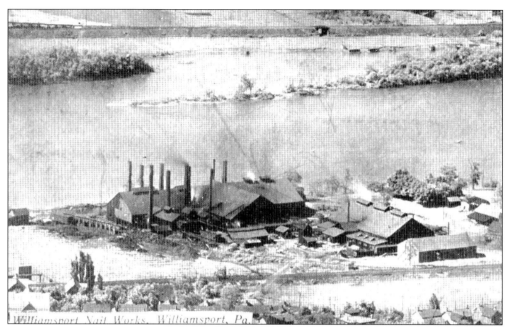

This aerial view of the Williamsport (Iron and) Nail Works, located in South Williamsport, was formerly one of many holding of Peter Herdic. (Thad Meckley collection.)

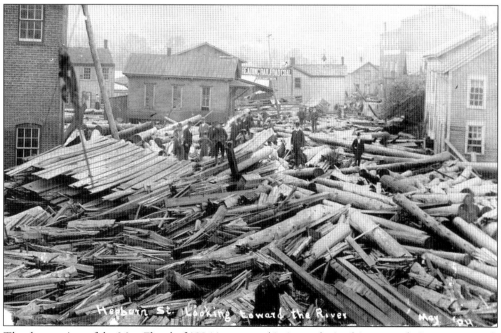

The devastation of the May Flood of 1894 is captured in its quake in this rare real picture postcard. The author's family lived right in this lower section of Hepburn Street, working in the lumber and shingle mills shown here. (DiBartolomeo collection.)

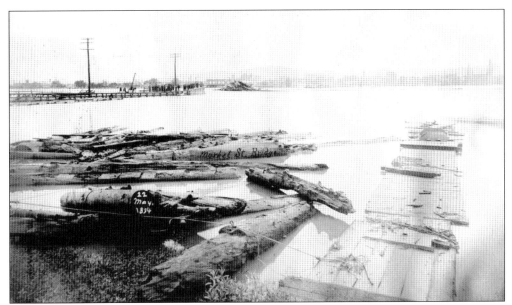

The toll of the May Flood of 1894 on the Market Street Bridge was recorded by local famed photographer D. Vincent Smith. The Market Street Bridge first opened for toll travel on July 5, 1849, but the St. Patrick's Day Flood of 1865 swept it away. It was rebuilt in December 1865 as a wire suspension bridge, but it too was swept away in the June Flood of 1889. An iron bridge was then built and later went toll-free in November 1891 after the county commissioners purchased it. (Will Fluman collection.)

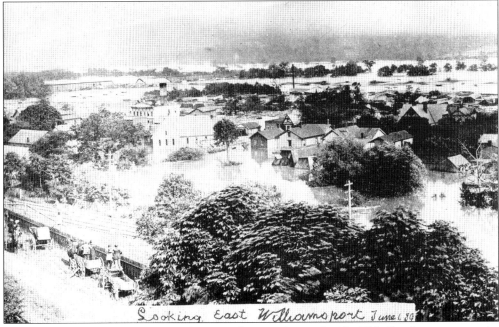

The June Flood of 1889 is captured in time by D. Vincent Smith. This flood swept away the Beaver Lumber Mill at the foot of Hepburn Street, which was built in 1854 by Benjamin H. Taylor and others, operating a sawmill there together until 1858. The mill came to rest on Randsom's Island at the mouth of Loyalsock Creek. (Will Fluman collection.)

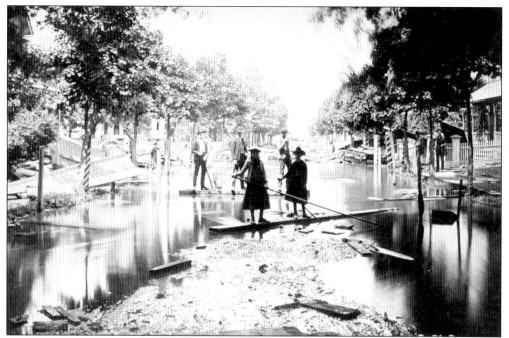

Vine Avenue is seen after the June Flood of 1889. During this flood, 280,000 feet of logs went down to the Chesapeake Bay, causing Williamsport mill owners to set up a co-operative mill at Sparrow's Point, Maryland, to retrieve and process the logs. (Private collection.)

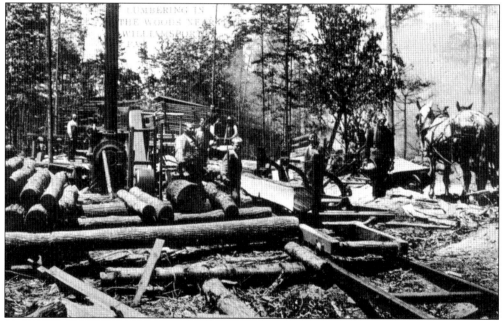

Lumbermen worked in the woods for $1 to $1.50 a day, working six days a week from sunup to sundown during the months of May through October. Often from November until April, the men left the camps during the felling times, spending their hard earned money until broke as they otherwise had nothing prior to spend it upon, receiving lodging and three square meals a day. (Springman collection.)

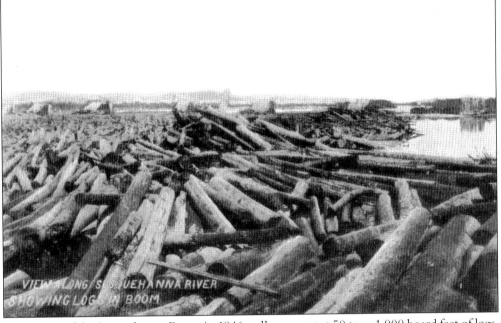

At the start of the Susquehanna Boom in 1846, tolls were set at 50¢ per 1,000 board feet of logs, and was open for business to anyone who wanted to use the service. The Common Pleas Court was to appoint a person to keep a track record of all transactions, including sales for logs not claimed. These tolls made the early owners millions, especially after Peter Herdic got control of the boom operations and raised the fees, serving as president from 1875 through 1878. (Taber Museum Collection.)

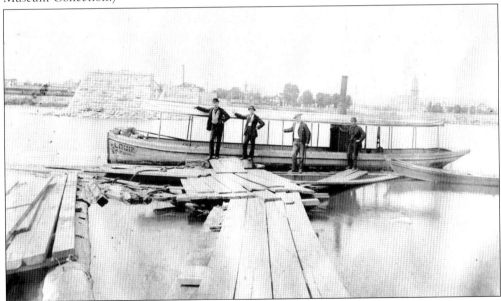

The Big Water Mill, the first sawmill erected in city limits in 1841, was destroyed during the night on November 9, 1862, when it was owned by Peter Herdic and Company. Built by the Williamsport and Philadelphia Lumber Company, it was built on cribbing extended into the river at the foot of Locust Street. (Will Fluman collection.)

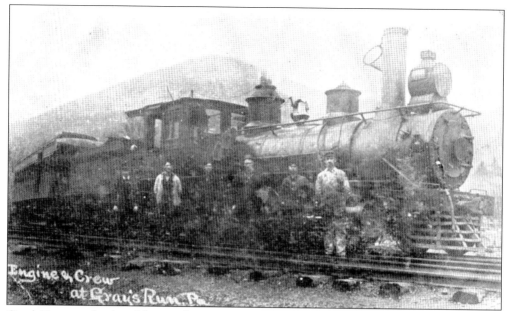

Gray's Run was the site of the Kindling Wood Mill, which harnessed the small mountain streams for power. The mill, like other remote lumber outfits, was built along the railroad lines that transported the lumber, supplies, and workers to and from the wilderness to the cities beyond. (Above, Thad Meckley collection; below, Will Fluman collection.)

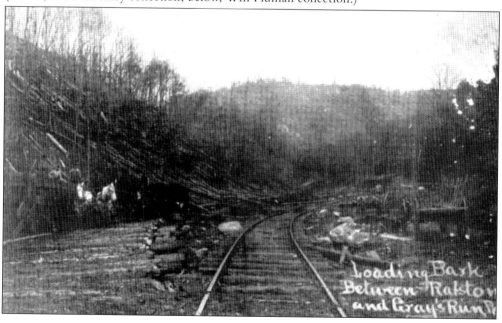

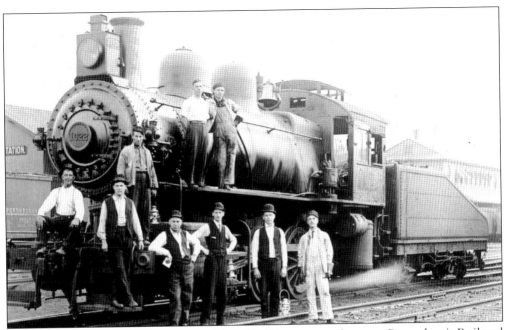

Lumber baron Peter Herdic used his wealth and influence to get the upper Pennsylvania Railroad station placed at the front door of his newly built grand hotel, the Herdic House, in 1865 as seen in this real-photo postcard. (Fagnano collection.)

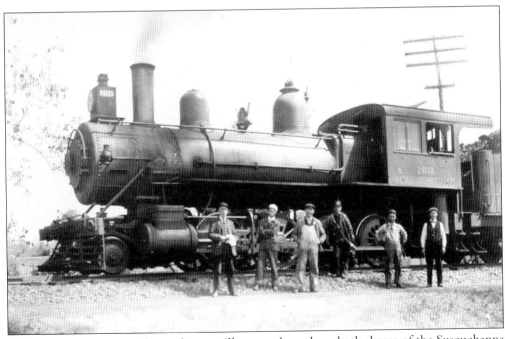

During the 1850s, more than a dozen mills popped up along both shores of the Susquehanna River. These mills attracted the eye of investors of the Sunbury and Erie Railroad, which virtually laid dormant with its plans to connect Sunbury and Williamsport since it was incorporated in 1837. (Private collection.)

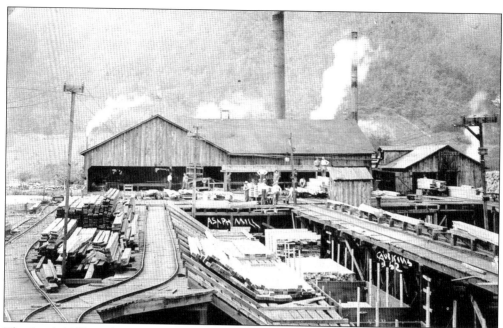

The Asaph Mill was located at the north end of the village of Asaph in Tioga County, where it quietly operated as a typical band and gang saw mill. It was owned by Eben B. Campbell and Girard G. Hagenbuch, of Williamsport. Note the four gondolas being loaded with special orders of lumber. (Will Fluman collection.)

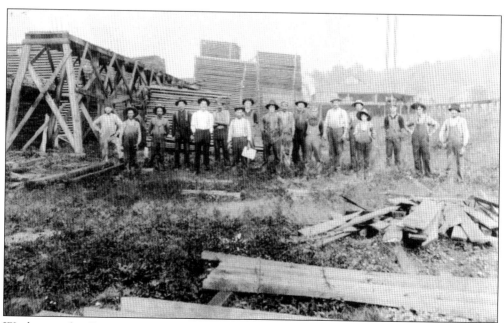

Workers at the C. W. Sones lumber mill at Masten, Pennsylvania, pose for this real–photo postcard. (Will Fluman collection.)

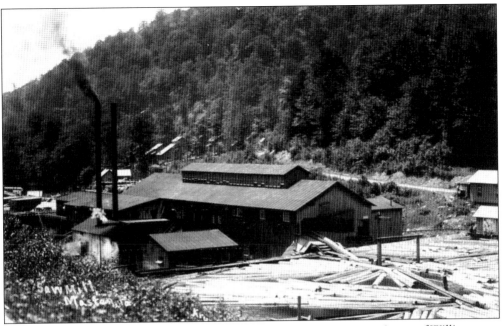

The Masten Mill in this real–photo postcard belonged to state senator C. W. Sones, of Williamsport, who milled hemlock and hardwoods there. (Daniel Bower collection.)

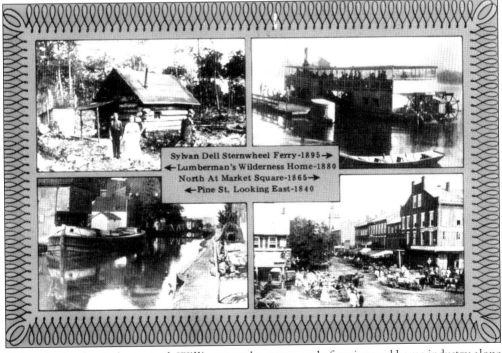

Sylvan Dell Sternwheel Ferry -1895 →
← Lumberman's Wilderness Home -1880
North At Market Square -1865 →
← Pine St. Looking East -1840

Before the lumber industry took Williamsport by storm, only farming and home industry alone prevailed as shown here. The abundance of the valley's virgin timber (hemlock and white pine) exploded the growth of the area in both population and wealth. (Thad Meckley collection.)

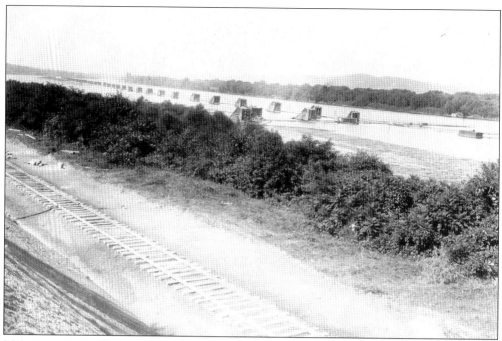

Maj. James H. Perkins is credited as having been the driving force behind the establishment of the Susquehanna Boom with fellow Maine lumbermen John Leighton having surveyed and designated its location. (Will Fluman collection.)

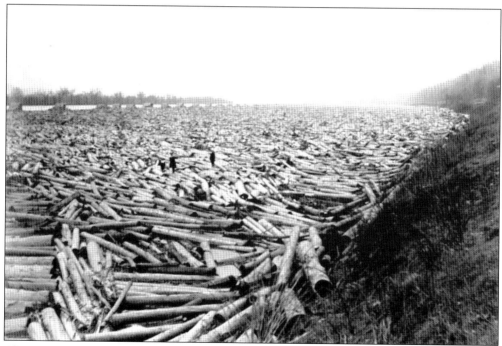

Christ Haist served as the final superintendent of the Susquehanna Boom, which is captured here by D. Vincent Smith around 1889. (Will Fluman collection.)

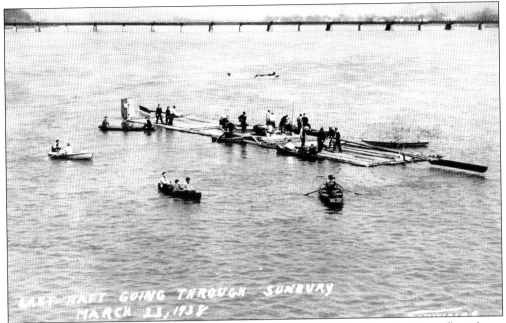

In memory of the logging days of old, old-timers constructed the "Last Raft" to float down the Susquehanna River as done during the logging era. The trip began on March 14, 1938, but on March 20, the raft struck the Muncy Railroad Bridge, seven passengers died, including Dr. Charles F. Taylor, Burgess of Montgomery, and Thomas Proffit, a Universal Newsreel cameraman. (Private collection.)

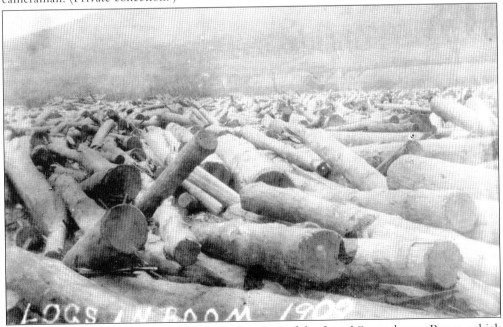

This 1903 boom shot shows one of the final seasons of the famed Susquehanna Boom, which by 1908 was dismantled. The last logs that floated down the river were, a year later, out of Pine Creek Valley area, ending Williamsport's Lumber Era of old when the last log was pulled out for the Brown, Clark and Howe Company. (Taber Museum Collection.)

The Pennsylvania College of Technology, a satellite campus of the Pennsylvania State University, sits upon the site of some of Williamsport's former lumber industrial plants. Oddly enough, Penn College continues to pay tribute to Williamsport's illustrious past, offering courses in forestry and building construction. (Thad Meckley collection.)

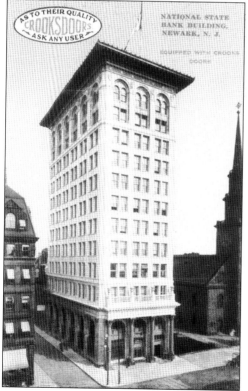

W. D. Crooks and Sons Veneer Door Company, of Williamsport, made the famous "Crooks Doors" that were a nationally recognized favorite, supplying its doors to the top buildings, including the hotel noted here. (Thad Meckley collection.)

Eight

CENTENNIAL OF WILLIAMSPORT

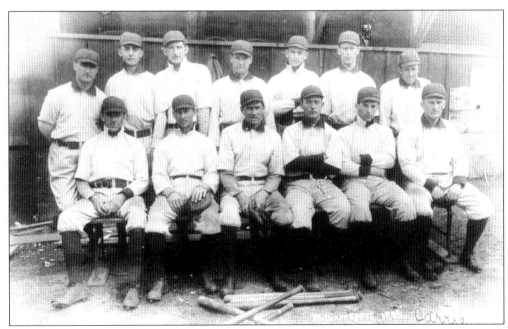

The 1906 "Millionaires" professional baseball team poses for their championship team photograph as seen in this real-photo postcard. The Williamsport centennial-year squad won the Tri-State League pennant that season. (Taber Museum Collection.)

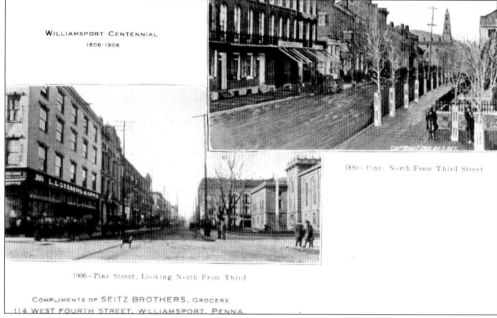

1850—Pine, North From Third Street

1906—Pine Street, Looking North From Third

COMPLIMENTS OF SEITZ BROTHERS, GROCERS
114 WEST FOURTH STREET, WILLIAMSPORT, PENNA.

One of a handful of centennial cards issued by local Williamsport merchants, this 1906 souvenir highlights grocers Seitz Brothers of 114 West Fourth Street. William Seitz lived at 914 Louisa Street while brother John lived at 630 Grace Street. (Daniel Bower collection.)

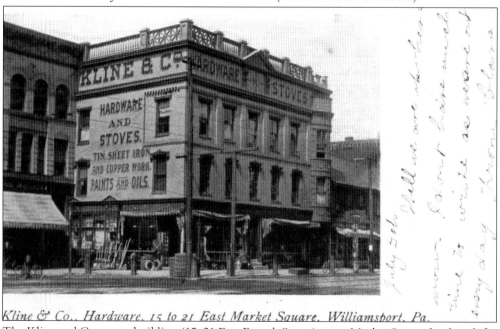

Kline & Co., Hardware, 15 to 21 East Market Square, Williamsport, Pa.

The Kline and Company building (15-21 East Fourth Street) was a Market Square landmark for many years, operating as a hardware store location via various owners, including Renninger's Hardware Store in the 1850s, Elliott's Hardware in the 1860s, and Dickie Grugan's in more recent years. The house was originally built as the home of local Pennsylvania Canal engineer and later lumber baron Robert M. Faries, who served also as an engineer for the North Central Railroad. (Private collection.)

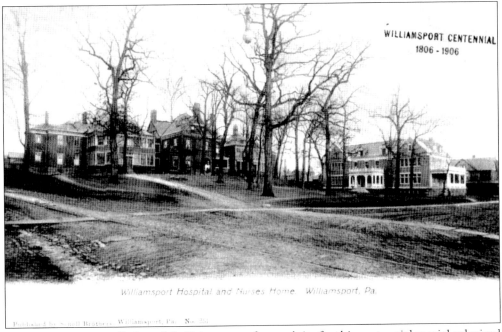

Williamsport Hospital's "new" facilities were a featured site for this centennial special colorized postcard, having formerly been located in the middle of downtown Williamsport and its floods for many years. In 1883, its nursing school was the third such school founded in the United States, being formed by Drs. Rita Church and Jean Saylor Brown. (Will Fluman collection.)

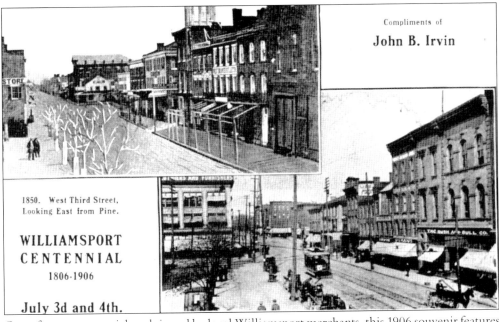

One of many centennial cards issued by local Williamsport merchants, this 1906 souvenir features John B. Irvin Shoes of 37 West Third Street. Irvin lived at 760 West Third Street at the time. (Daniel Bower collection.)

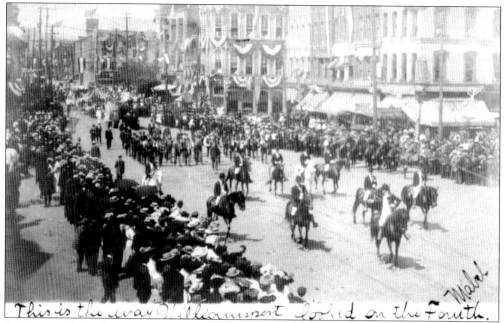

A glimpse of the festivities on the centennial Fourth of July is recorded for posterity in this commercialized real-photo postcard sold most likely by a traveling street vendor photographer. (Daniel Bower collection.)

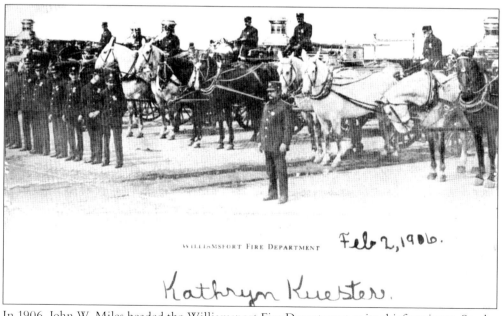

In 1906, John W. Miles headed the Williamsport Fire Department as its chief engineer. Sender Kathryn Kuester lived at 409 Louisa Street. Williamsport had its first meeting to form an organized fire department in April 1826, meeting then on September 26, 1827, to elect officers. (Private collection.)

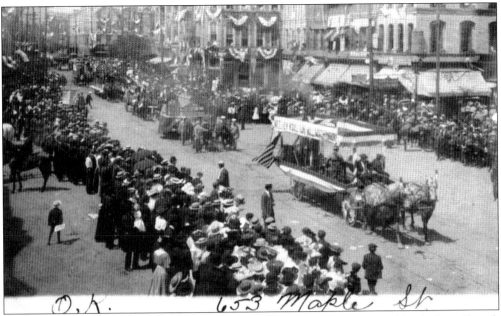

Market Square was filled with Williamsporters and visitors from miles around for the huge Fourth of July centennial parade in downtown Williamsport, starting at 10:00 a.m. that Wednesday, with six divisions comprised of "civic, industrial, mercantile, historical, military, secret society and social organizations." (Springman collection.)

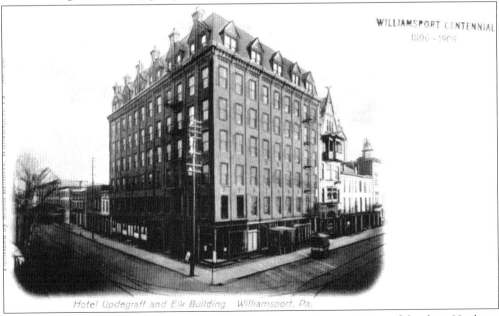

In late June 1891, the Hotel Updegraff came into being as the proprietors of the then-Hepburn House changed the name in honor of Daniel Updegraff. The Updegraff was noted as receiving one of the earliest telephone booths in town on Saturday, October 1, 1892. It was constructed of oak and had plate glass windows on three sides. Owner Daniel Updegraff Sr. died on Monday, February 16, 1903, at his home in Newberry at the age of 86. Updegraff was "one of the pioneer settlers of the (downtown) district." (Fagnano collection.)

Clothier and merchant tailor Moses Ulman's mansion along elegant West Fourth Street, also known as Millionaires' Row, is still in its prime in this real-photo postcard since being built by pioneer lumberman Henry B. Smith around 1870. In 2006, 634 West Fourth Street serves as the Annunciation Church rectory and home of its head priest. (Private collection.)

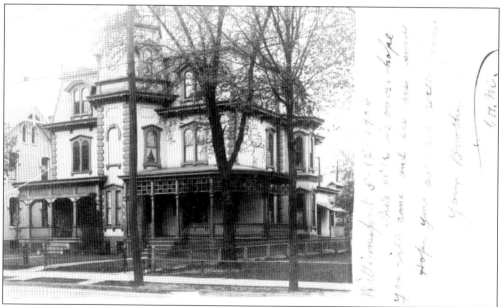

The crown jewel of all "Herdic Double" residences, 942-944 West Fourth Street is shown in 1906, having been built by Williamsport's premier entrepreneur and developer Peter Herdic. This is one of many Mansard-roofed brick doubles houses, which Herdic built in the surrounding neighborhoods to encourage families to move to "his part of town." George H. Muir, of Muir and Metlzer (dry goods and carpets), lived at 942 while attorney Jonathon Strieby, Williamsport's city solicitor, lived at 944 in 1906. (DiBartolomeo collection.)

Fresh as the day in 1880 when it was built, the Lemuel Ulman family mansion (411 West Fourth Street) was built on land purchased in 1878 from the neighboring Peter Herdic estate at 407 West Fourth Street. Ulman worked in the family business, M. Ulman Sons, Clothiers on Market Square. (Private collection.)

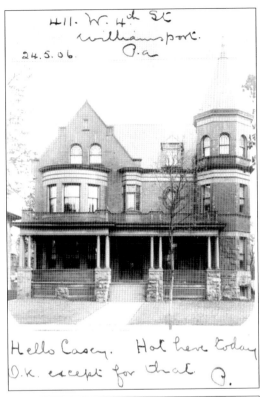

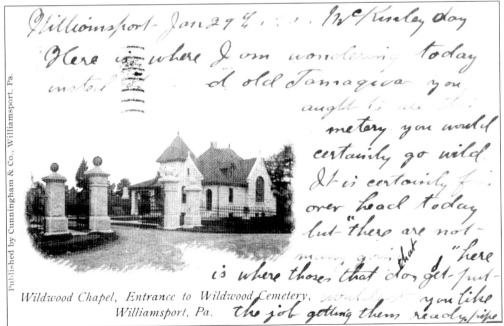

Wildwood Cemetery was incorporated August 18, 1863, with its first interment, David Smith (age 61), taking place on January 1, 1864. Petitioners for this beautiful 50 acre-maximum cemetery were Clinton Lloyd, James Armstrong, William H. Armstrong, John McMinn, Thomas Smith, George W. Youngman, V. S. Doebler, George W. White, and Peter Herdic.

ACROSS AMERICA, PEOPLE ARE DISCOVERING SOMETHING WONDERFUL. *THEIR HERITAGE.*

Arcadia Publishing is the leading local history publisher in the United States. With more than 3,000 titles in print and hundreds of new titles released every year, Arcadia has extensive specialized experience chronicling the history of communities and celebrating America's hidden stories, bringing to life the people, places, and events from the past. To discover the history of other communities across the nation, please visit:

www.arcadiapublishing.com

Customized search tools allow you to find regional history books about the town where you grew up, the cities where your friends and family live, the town where your parents met, or even that retirement spot you've been dreaming about.